CROSSI

IMAGES
of America

CENTRAL WEST END

ST. LOUIS

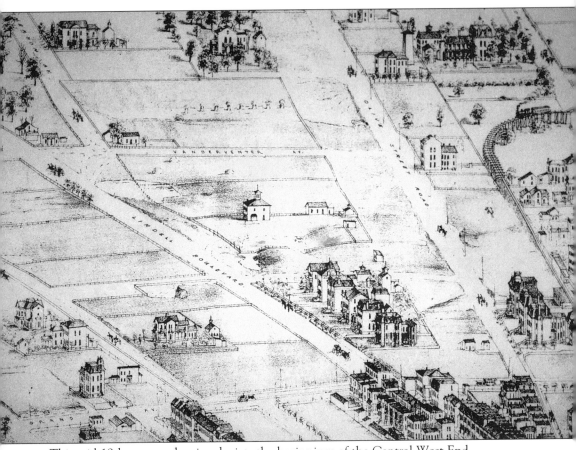

This mid-19th century drawing depicts the beginnings of the Central West End.

Cover Image: This image, taken in 1916, shows one of the first service stations in St. Louis at 4614 Washington Blvd.

IMAGES of America

CENTRAL WEST END

ST. LOUIS

Albert Montesi and Richard Deposki

ARCADIA

Published by Arcadia Publishing,
an imprint of Tempus Publishing, Inc.
3047 N. Lincoln Ave., Suite 410
Chicago, IL 60657

Printed in Great Britain.

Library of Congress Catalog Card Number: 00-109619

For all general information contact Arcadia Publishing at:
Telephone 843-853-2070
Fax 843-853-0044
E-Mail sales@arcadiapublishing.com

For customer service and orders:
Toll-Free 1-888-313-2665

Visit us on the internet at http://www.arcadiapublishing.com

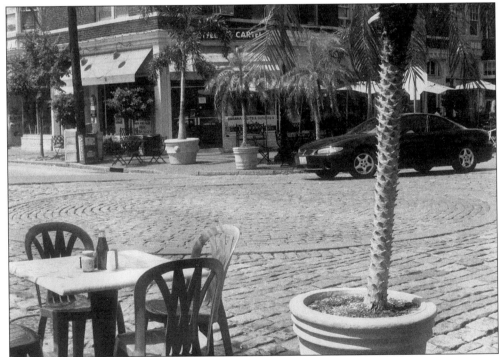

This rounded space, which lies slightly off Euclid, was once said to be used as a watering ring for horses. It symbolically captures the charm of Euclid and the West End, remaining a locale closely connected to the good taste of the Victorian past.

4

CONTENTS

ACKNOWLEDGMENTS

We want to thank the following for their great help in the making of this book:

St. Louis University Archives: Randy R. McGuire

St. Louis University News Bureau: Clayton Berry

The Muny: Laura Peters-Reilly

Metropolitan Sewer District: Frank E. Janson

Jack Parker

Thelma H. Blumberg

Fox Associates: Julie Lena

Lawrence Amitin

St. Louis Zoo: Charles Hoessle

St. Louis Public Schools Record Center/Archives: Sharon A. Huffman and Gloria Harris

School Sisters of Notre Dame

Washington University Archives

Jefferson Camera Shop

INTRODUCTION

Envision a riverport town in the 1860s—its bustling river traffic alive with boats and men. Here, docked in symmetrical rows, giant paddle wheelers were manned by shouting roustabouts hustling freight. This was the St. Louis that Mark Twain and Edna Ferber wrote about: a town alive on the banks of the great, mysterious, and profitable Mississippi. This river, later called "the great brown god" by native-son T.S. Eliot, brought a wealth of trade to the city's wharves. And, with the construction of the miraculously engineered Eads Bridge, St. Louis became the gateway to the great opening West. The town grew rich.

The Civil War, with its 800,000 dead, nearly destroyed the United States of America; as well, it forced St. Louis, like the rest of the country, to reinvent itself. In the face of fierce internal division between Union and Confederate sympathizers, St. Louis profited from her war contracts with the Union. Even further, the river and the war produced merchant princes, speculators who grew enormously rich. To display their wealth, they looked about the city for private locales where the real estate could grow as their mansions and gardens did. The first baronial edifices were in such secluded locales as Lucas Place and Lafayette Square, but soon these too were threatened by vulgar intrusions—Lucas Place was endangered by the smells and noise of the surrounding industrial city and Lafayette Square by the presence of immigrants in nearby Soulard and by the devastation of the 1896 tornado. Their eyes turned to the city's western limits where they built mansions, schools, and churches that would rival those in Boston, Philadelphia, and New York. This newly discovered neighborhood became known in time as the Central West End or CWE.

The city grew in size and prestige to become, by 1904, the fourth most populous in the nation. Two of the great successes that drew the merchant elite were the 1904 World's Fair and the newly landscaped Forest Park. The Park was located near Euclid Avenue—an area of the city that would later become its Bohemian quarter. The new elite migrated in record numbers to the area surrounding the Park; they built stately mansions and manicured gardens in enclaves that were deemed private by law and guarded by a security force that lived in gatehouses and policed the area. They gave their estates respectable old names, including Westmoreland Place, Portland Place, Vandeventer Place, Kingsbury Place, and Hortense Place, among many others.

What these migrants did not foresee was the decline and urban blight the city would suffer before and after World War II. They had no idea their children would move out of the city in droves to a county that would become a hodgepodge of independent towns, nor did they realize that their magnificent homes and streets, and their snobbery, would become forgotten by the generations that followed. This story is, therefore, a tale of two cities: one story tells of the city's

prestigious past, the St. Louis of the late 19th and early 20th centuries; the other speaks to a city in decline, the St. Louis of the Depression and of pre and post-war America.

Today, the cultural clock is fortunately beginning to swing in the opposite direction: the city, groaning under neglect, has begun to show a greater vitality. A renaissance is beginning to take place as all eyes are turned once more to the period when St. Louis experienced its finest moments. The drive is to bring some of that period's finest features back to their rightful roles in our contemporary life, to restore them, to nurture them, and to maintain them at any price. No longer will we paint over the ceiling of the majestic Union Station with horrid black paint. One early success of this fight has resulted in the making of parts of the Central West End into a historic district. This included an area bound by Delmar, Lindell, and Euclid-Boyle. As a result, the most treasured buildings and the institutions with historical and cultural significance in the CWE will be protected from decline and destruction. But the battle has just begun; we hope that it will continue.

We begin our account of the growth and development of the West End with the confrontation of Union and Confederate sympathizers at Camp Jackson in the early days of the Civil War. The Unionists overcame the Confederates at this encampment. At the time, this army installation marked the western limits of the city and the beginning of the acreage that would become known as the Central West End.

One

THE BEGINNINGS

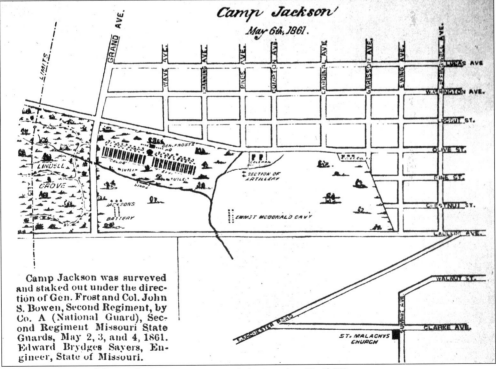

Camp Jackson was surveyed and staked out under the direction of Gen. Frost and Col. John S. Bowen, Second Regiment, by Co. A (National Guard), Second Regiment Missouri State Guards, May 2, 3, and 4, 1861. Edward Brydges Sayers, Engineer, State of Missouri.

Above is a map of Camp Jackson as it existed during the Civil War.

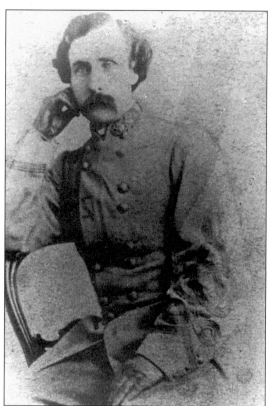

On the left is an early portrait of General Marshall Frost, whose forces at Camp Jackson were summarily taken prisoner by the Unionists. German immigrant soldiers, under the command of Captain Nathaniel Lyon, made the arrests.

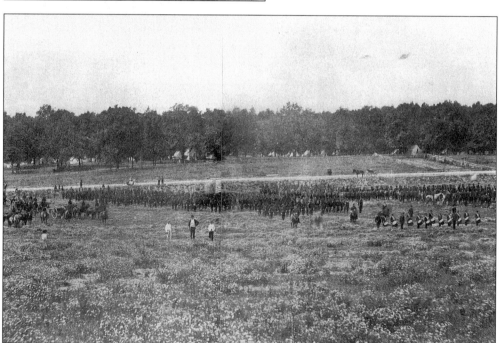

This is Camp Jackson as it appears two years later, solidly under the control of the contingent of Union troops pictured here.

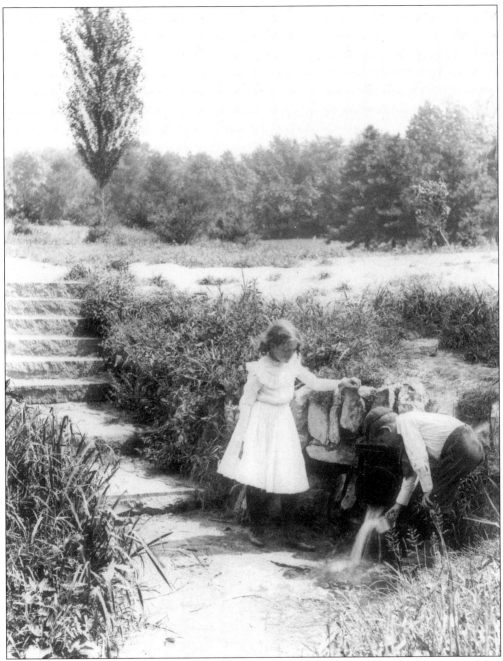

Here two youngsters drink from the Cabanne Spring in the 1870s. This spring was part of the early Forest Park.

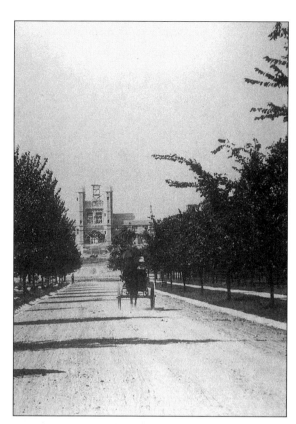

This rider and his buggy are enroute to a building that later will be known as Brookings Hall, Washington University.

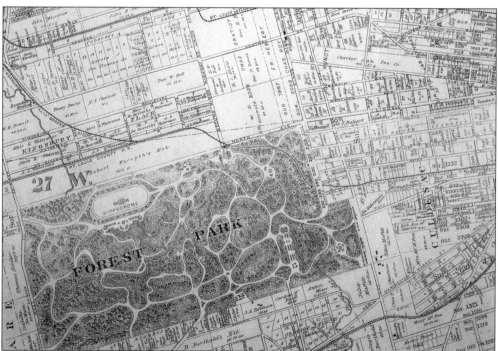

Above is a map of the Central West End with its earliest demarcations.

Two

FOREST PARK

Once the largest public park in the nation, Forest Park had an expanse of 1,374 acres. At the time of its dedication in 1876, it was a tract of open forest land with a small river running through it. It has been transformed today into an entertainment center of museums, theatres, a zoo, a skating rink, and dozens of playing fields of all sorts and kinds—all with little or no admission charge.

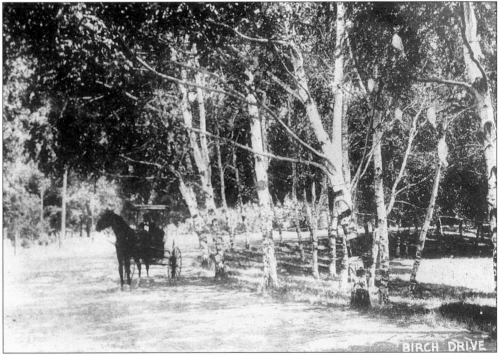

Here in somewhat sylvan bliss, a buggy proceeds tranquilly on Birch Road in Forest Park. In its earliest days, before it was landscaped as a site for the 1904 Fair, the grounds were unspoiled rural areas.

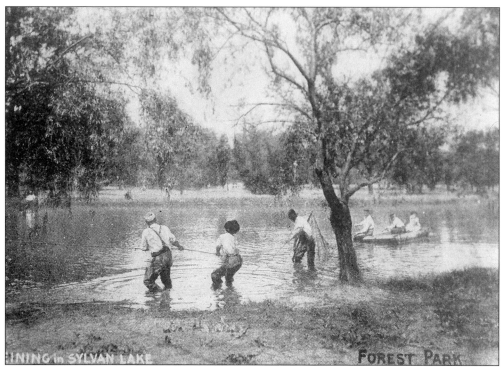

Fishermen seining for fish in Forest Park when this lake and others were generally free and uncultivated.

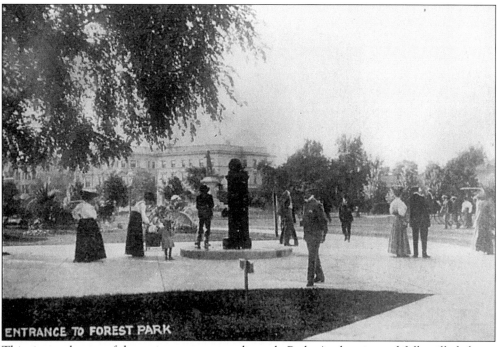

This site marks one of the main entrances to the early Park. As the pictured folk milled about, they seem to be using this locale as a meeting point.

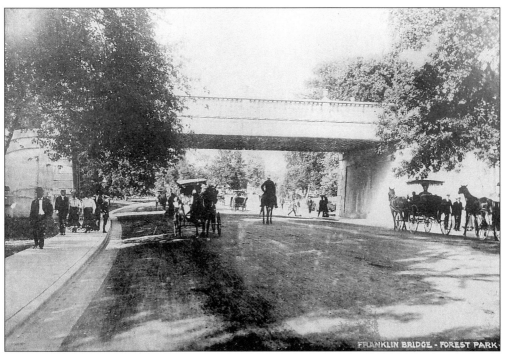

Here is another cameo-setting of the life-world of the Park. At this Franklin bridge span, one can see in small the foot and horse traffic of the period.

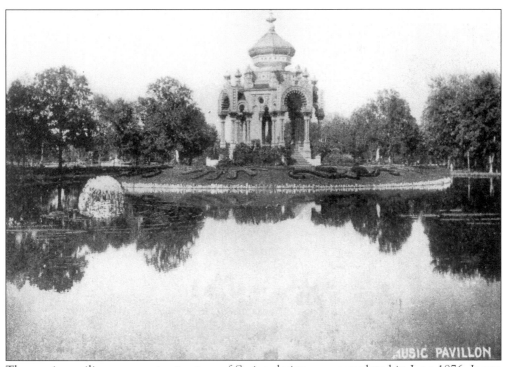

The music pavilion, an ornate structure of Syrian design, was completed in June 1876. It was used as a bandstand until it was damaged by a storm and demolished in 1912.

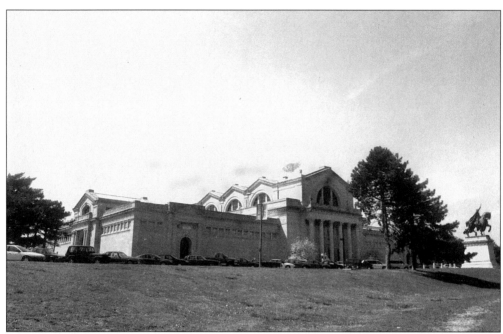

Originally erected for the 1904 Fair, the St. Louis Art Museum—then known as the Fine Arts Palace—has endured to this day as the city's most prestigious art museum.

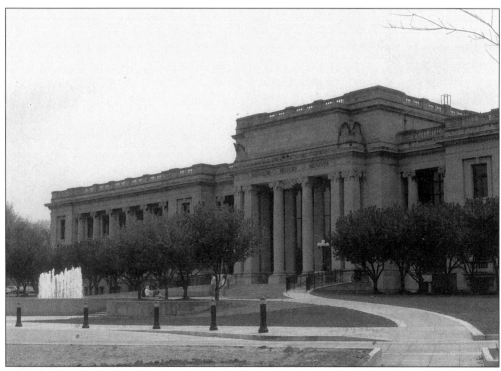

After the Fair had closed, the city set to work to reconstruct the Park. One of the buildings erected as part of this re-creation was the Jefferson Memorial Building. Today, it is occupied by the Missouri Historical Society.

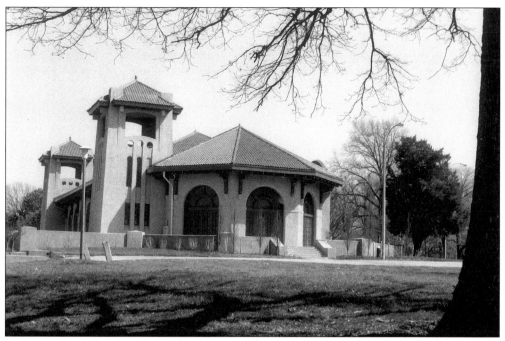

Built originally after the World's Fair as part of the reconstruction of the Park, the Pavilion was restored in 1980 at the cost of $350,000.

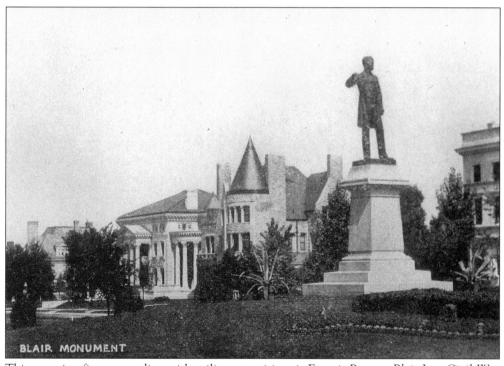

BLAIR MONUMENT

This towering figure, standing with military precision, is Francis Preston Blair Jr.—Civil War general, representative, senator, and statesman. This statue is located prominently at one corner of the Park facing the city's streets.

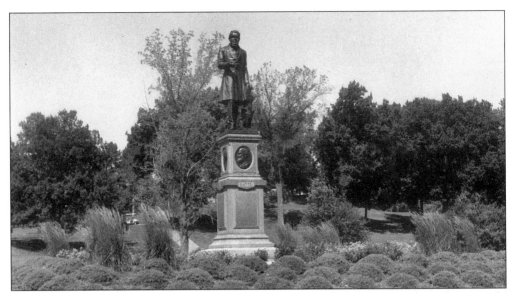

Another statue of consequence is that of Edward Bates, attorney general in the Lincoln Administration. It was originally erected in 1876 and was later moved to its present location when Highway 40 was cut through the Park.

One of the problems in maintaining the early Forest Park was the presence of the River des Peres running through it. Although the stream was narrow at best, it did flood in intense rainy weather, sending water into the streets and neighborhoods that bordered the Park. In order to fight these adverse conditions, city engineers were instructed to enclose the river in giant underground pipes.

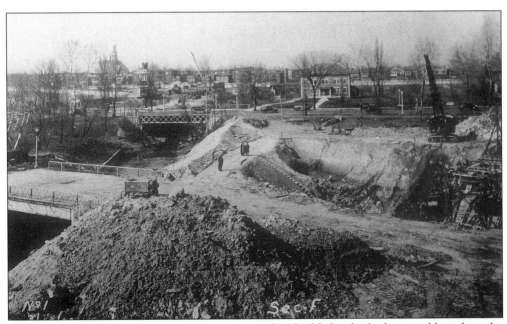

In March of 1930, city sewer engineers excavated to build the ditch that would enclose the stream in a giant pipe system.

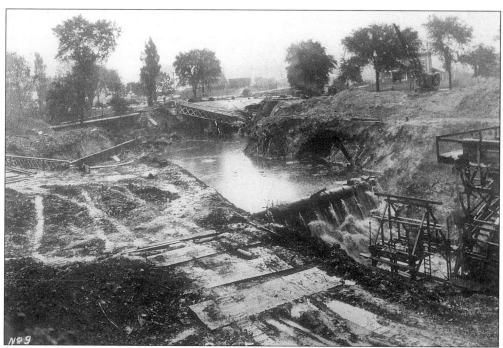

Another view of the construction site during the preparation for the laying of the giant pipe (which was 29-feet wide and 23-feet high). Here a bridge has collapsed in the process.

Ball fields in the Forest Park acreage are shown above. Here is a long-range shot of the Park with its open fields against the towering Chase Park Plaza Hotel in the far distance.

The fountain on Government Hill—reminiscent of the gushing fountains of the World's Fair—was constructed at the bottom of Government Hill; the World Fair Pavilion acted as a faraway backdrop.

Erected in 1956 by the American Jewish Tercentenary Committee of St. Louis, the Jewish Memorial commemorated the first Jewish Settlement at New Amsterdam in 1654.

The German-American community of St. Louis erected this statue of Franz Sigel in Forest Park in 1916 to honor the Union Civil War commander.

This conciliatory piece, honoring the Confederate dead, was erected in 1914 by the Ladies Confederate Monument Association.

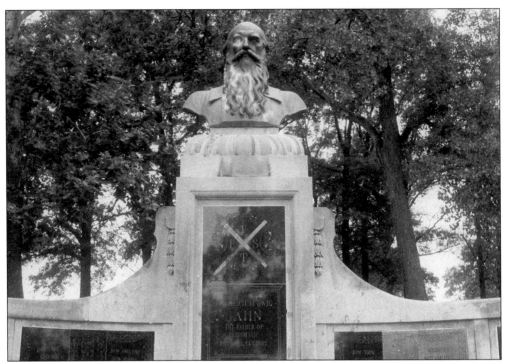

Various German Turnverein groups erected this memorial in 1913 to honor Frederich Ludwig Jahn, the founder of the Turnverein (an athletic organization).

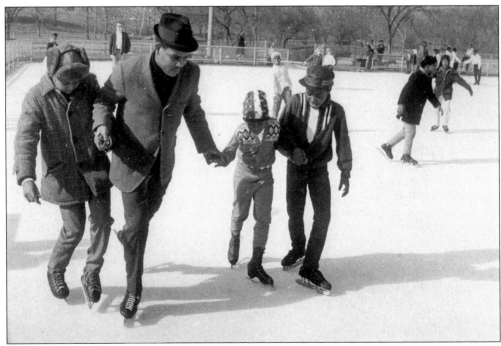

The Steinberg Ice Skating Rink, a gift of the Mark C. Steinberg Charitable Trust, was opened in 1957. It sits in the eastern section of the Park.

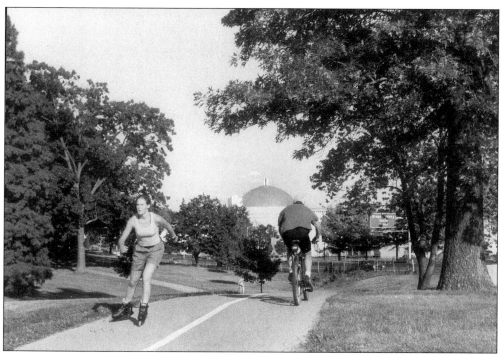

This is a shot of the bicycle path that winds through the Park. At the beginning of the last century, the bicycling craze was so great that this course was created for its use.

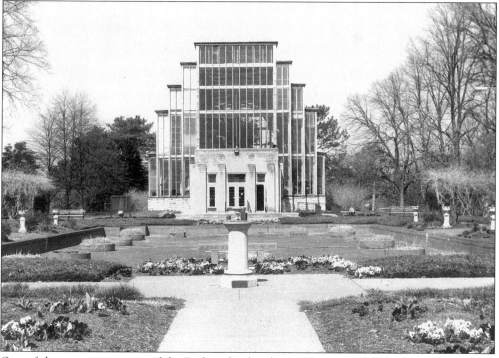

One of the great ornaments of the Park is this lovely greenhouse, called the Jewel Box, which features seasonal displays of various plants and flowers.

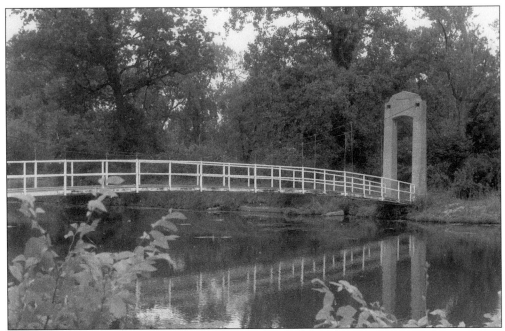

The Park has become a mass of courts, fields, courses, and other athletic centers. Most of these were created by the famous Park athletic director, Dwight Davis (for whom the Davis Cup international tennis tournament is named). Here, a bridge connects one hole to another on the golf course.

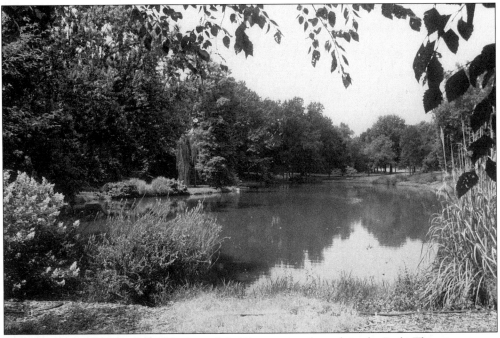

The lake pictured here is one of the many lakes, lagoons, and ponds in the Park. This picturesque waterway cannot be appreciated from the road that almost abuts it, but must be seen from the interior of the Park to fully be appreciated. It is called "Lake" after the nearby street.

24

Three
THE 1904 WORLD'S FAIR
AND THE
OLYMPIC GAMES

The greatest single event that ever took place in the Forest Park was the 1904 Louisiana Purchase Exposition; it was generally known as the 1904 St Louis World Fair. Presented to commemorate the purchase of the Louisiana tract from Napoleon, the Fair absorbed many acres of the Park's grounds. The Fair itself, the largest of its kind, was a world-success with its classic buildings, lagoons, a carnival area, cascades, and gardens. Most people agree that its presentation was St Louis' finest moment.

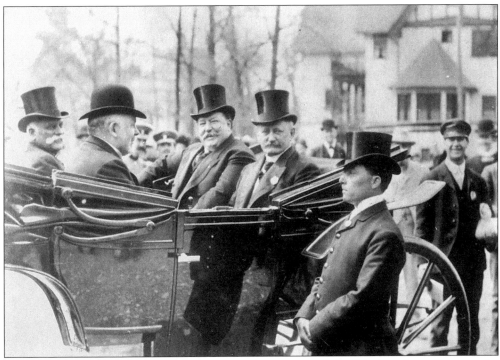

In April 1904, thousands thronged to enter at the opening of the Fair in order to listen to the opening address by William Howard Taft, the current secretary of war under Theodore Roosevelt. He is pictured with the talented president of the Fair, David Francis, and other dignitaries in this early automobile.

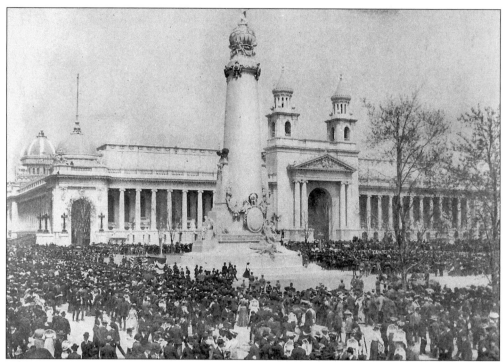

A view of the mass of visitors gathered about the Column of Progress on the Fair's opening day is shown above.

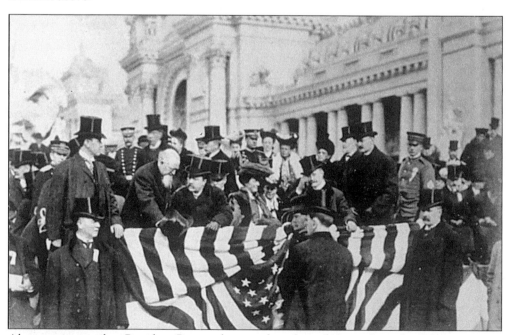

Also on opening day, President Roosevelt pressed a telegraph key—from the White House—that flooded the Fair's hundreds of buildings with electric light, stunning the visitors with the power of the recent invention. In November of 1904, President Roosevelt, pictured here among Fair officials, arrived at the Fair in person.

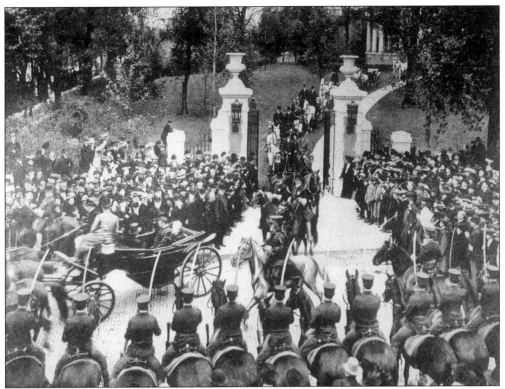

This was one of the many parades that attended the opening. During the several months of the Fair, there were bands playing and marching almost every day.

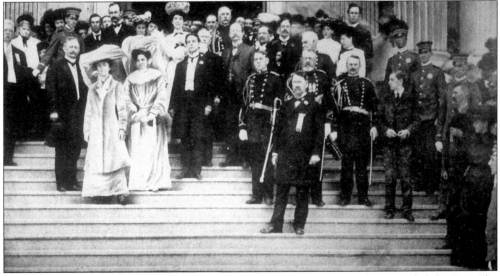

The much admired daughter of the president, Miss Alice Roosevelt, also attended the Fair. She is shown at the Illinois exhibit in a group photo that included the Fair president, David Francis.

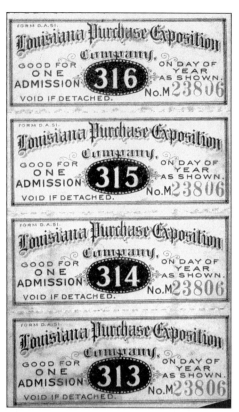

For the price of 25¢, one could buy admission to the Fair. A batch of the required ducats are pictured here.

A carnival atmosphere reigned in the amusement center called "the Pike." There, an almost endless array of exhibits, shows, and tests of strength ran for miles. This was the Fair's most popular spot for children and adults alike.

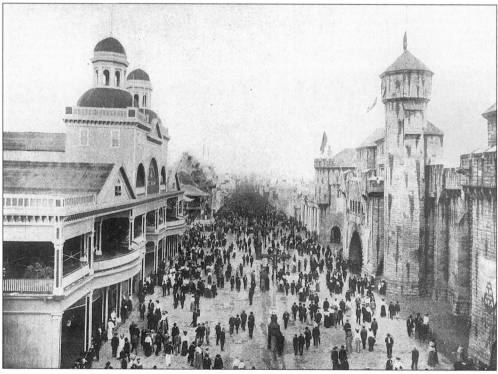

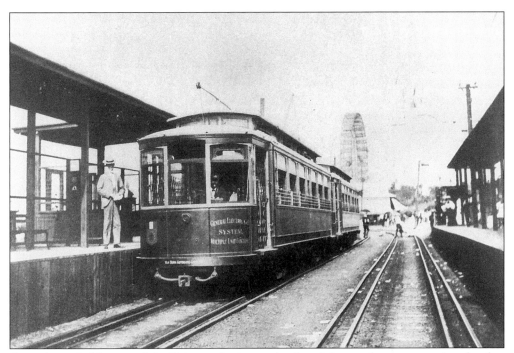

A much needed feature of the Fair was the internal railroad that made stops at various locales. The train allowed people to see things that would have been inaccessible on foot.

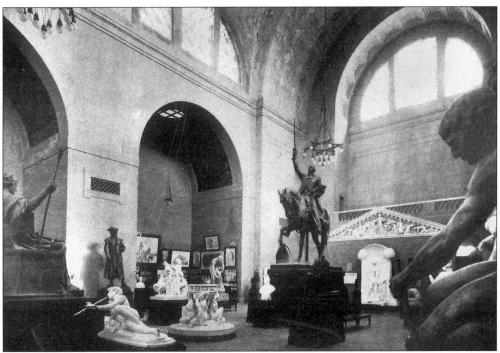

Much admired was the American Sculpture section at the Palace of Fine Arts (which later became the Art Museum). On display were world-class pieces by such American artists as Charles Niehaus and Daniel Chester French.

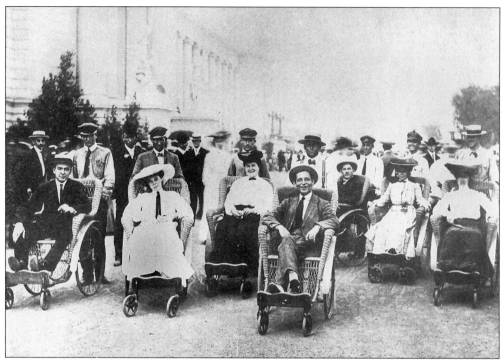

There were, as we will see, various amusing modes of transportation featured at the Fair. Pictured above are roller chairs that could be rented for 60¢ per hour. It was one means of resting while viewing the many aspects of the enormous Fair.

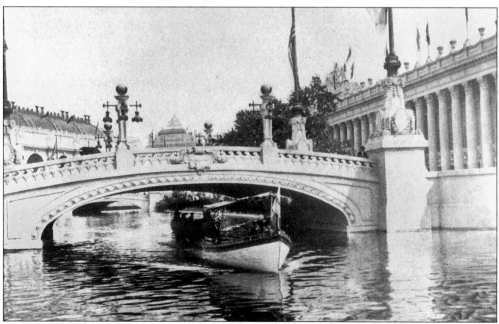

An additional way of traveling through the Fair was by boat on connecting waterways. This electric launch skimmed the waters at a rapid rate. Other water passage could be provided by gondolas and gondoliers imported from Venice.

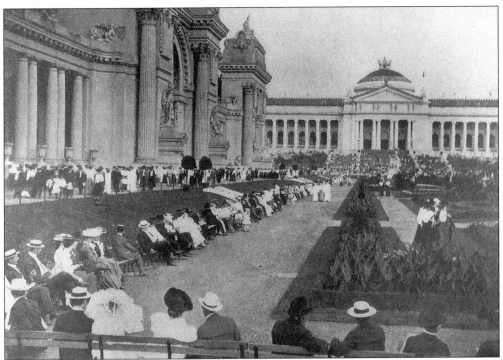

Nowhere has an attraction such as the so-called "sunken garden," a horticultural wonder, provided visitors with so much serenity for reflection. Built 3-feet under sidewalks and swards, this display of flowers attracted scores of contemplative people who came only to watch the garden.

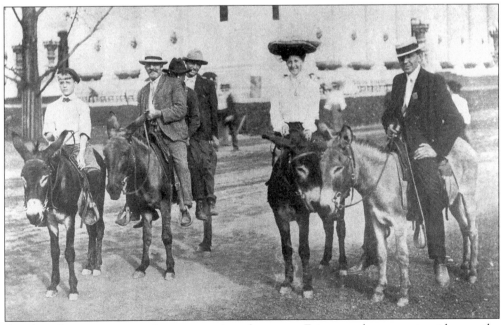

Another favorite means of transportation for some Fair attendees was to ride on the unpredictable burro.

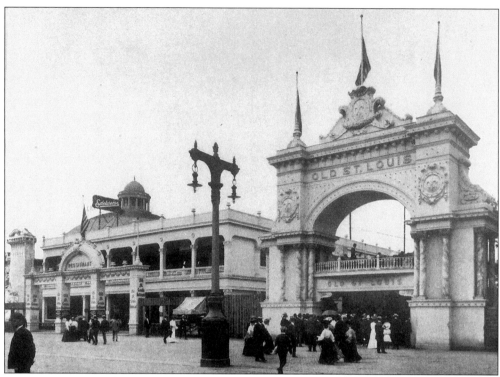

The Fair's tribute to St. Louis history was this re-creation of the town as a trading post. On display were 18th century artifacts and a duplication of the old Spanish town of 1781.

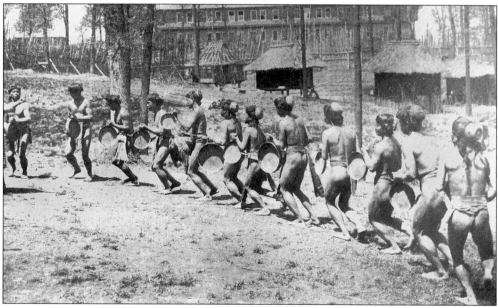

One of the most heavily frequented exhibitions of the Fair was devoted to various indigenous people from around the globe. Here we see the tribal dance of the Igorots, a people brought to the Fair from the Philippines. In the future, the Fair would be criticized for its attitude towards native peoples and their customs.

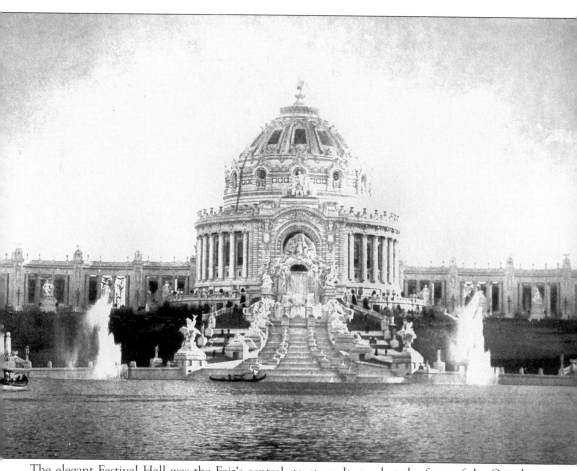

The elegant Festival Hall was the Fair's central structure. It stood at the front of the Grand Basin, where its elegant stairs lead to the Basin's cascades of rushing water.

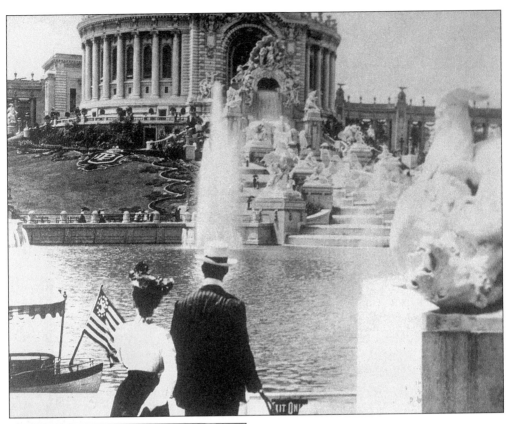

This is a view of the Festival Hall and the Grand Basin as it must have appeared to an admiring couple standing on the walkways surrounding the waters.

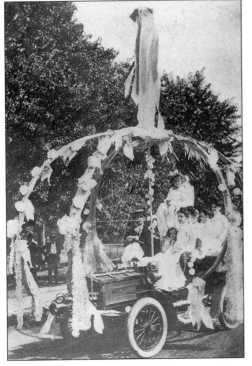

Of the Fair's many daily parades, none was more admired than the Liberal Arts Parade. Among the entries on August 27, 1904, was this highly decorated automobile. It won a prize for the best float.

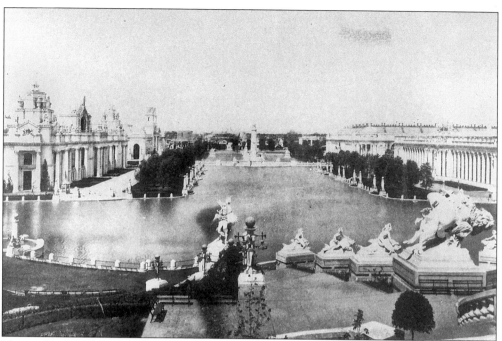

Here is the Grand Basin, viewed from the St. Louis Plaza. Note the row of maple trees that form a symmetrical pattern around the waterway.

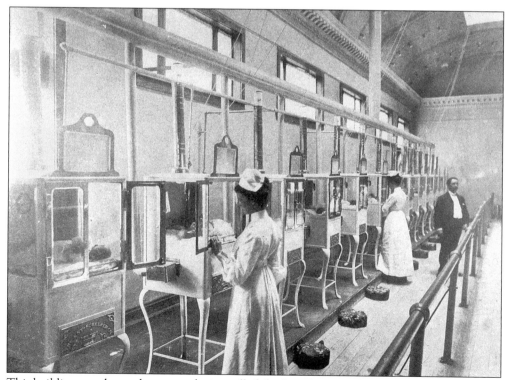

This building was devoted to a new device called the "incubator." These life-restoring machines helped nurse struggling infants to good health.

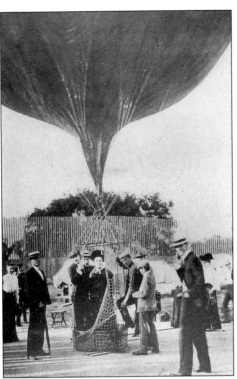

Among the Fair's many attractions were early balloons and airships. Here, daring passengers were lifted into a balloon for a thrilling ride.

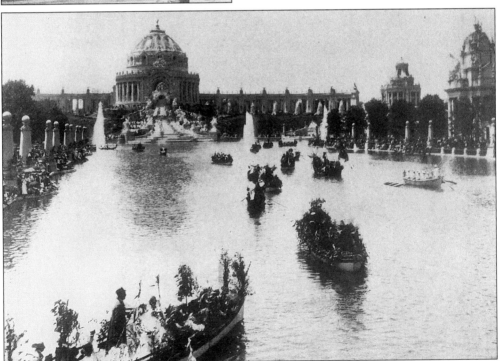

One of the Fair's most stirring events was the Water Carnival, which was occasionally staged on the Grand Basin. Boats were decked with flowers, banners, flags, and rows of colored lights to delight the intently watching spectators.

The zebu racing cart was another exotic means of transportation that delighted the Fair's visitors. The zebu was bred in India for racing purposes; the passenger was of the domestic variety.

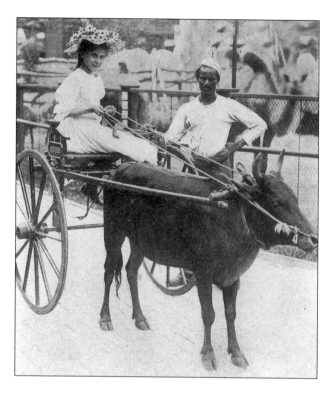

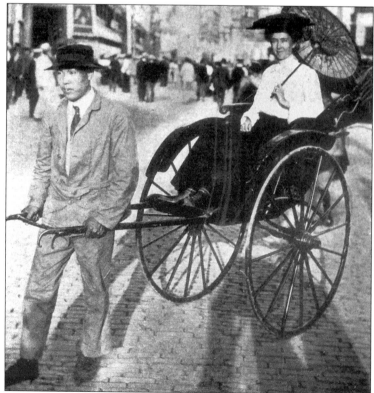

Here is yet another way to ride: a rickshaw with an Asian attendant escorts a lady with a parasol.

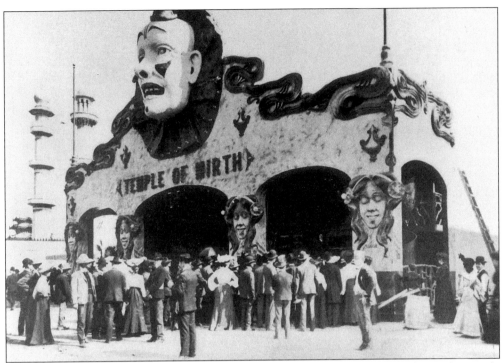

The Temple of Mirth, the Fair's "funny" concession, had three different shows that made audiences shriek with laughter. All of these shows appealed to the masses of people on the Pike, particularly the young folk.

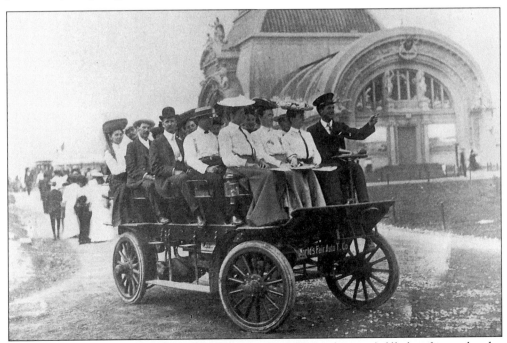

Here's an early-day automobile (looks more like an automated wagon) filled with people who listened as their trusted driver pointed out various buildings at the Fair.

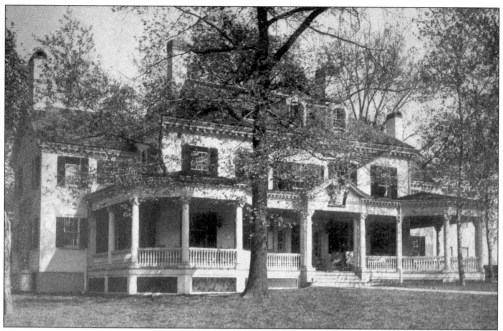

This house is a replica of the old Ford House in Morristown, NJ. General Washington used it as his headquarters during the Revolutionary War. After the Fair's dismantling, it was rebuilt. It still exists in St. Louis County.

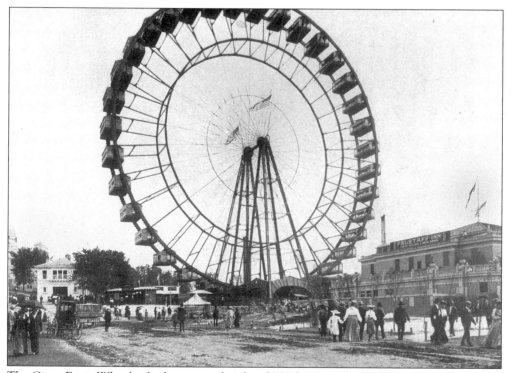

The Giant Ferris Wheel, which rose to a height of 250 feet, was the Fair's most popular ride. Its large cars could accommodate a good number of passengers.

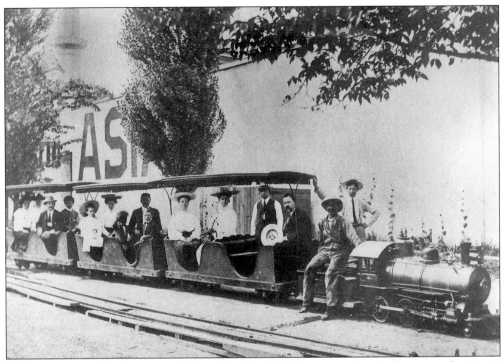

This miniature railroad ran up and down the Pike. Unlike newer, electrically-powered trains, it ran on old-style energy—fueled by coal, steam, and an engineer.

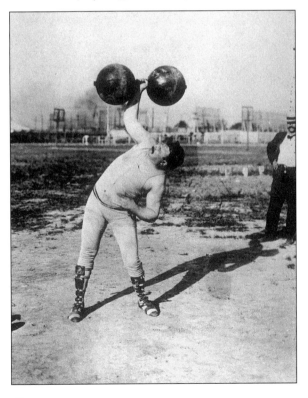

Recently named the United States' number-one sports town, St. Louis has always loved athletic competition. The Fair was the stage for the first Olympics on American soil. Here, a strongman with barbells sweats for a win.

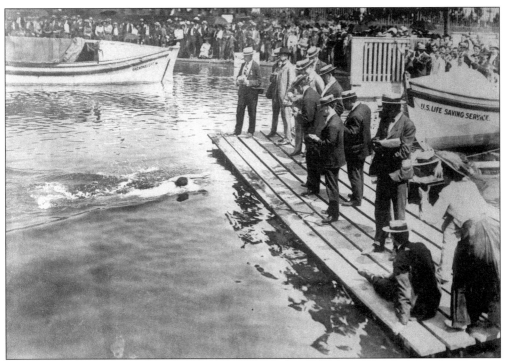

Another important Olympic contest was the half-mile swimming handicap. This shot is of the winner (a New York club woman) approaching the final stage.

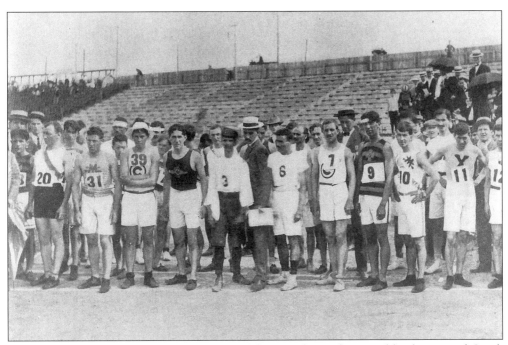

A gathering of runners lined up for the start of the marathon. This race, like the original Greek run, was 25 miles of cross-country running. Three hours and twenty minutes later, an Englishman, Thomas J. Hicks, would cross the finish line.

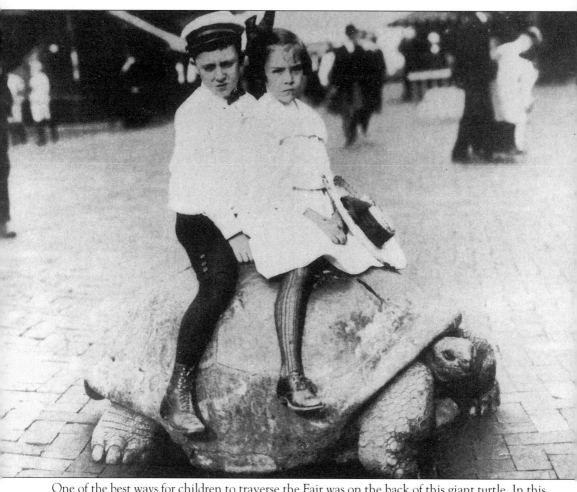

One of the best ways for children to traverse the Fair was on the back of this giant turtle. In this Mother-Goose manner kids were transported to their own never-never land.

Four
THE ZOO

The St Louis Zoo was started almost by accident. To honor the World's Fair of 1904, the Smithsonian Institute sent a vast bird cage. After the Fair closed, the City purchased the large aviary to house the birds. In 1913, 77 acres of Forest Park were allotted to house the animals left by their owners after the Fair. These animals, the aviary, and the 77 acres were the foundation for a permanent zoo. It grew through building and acquisitions until it became one of the country's leading zoos.

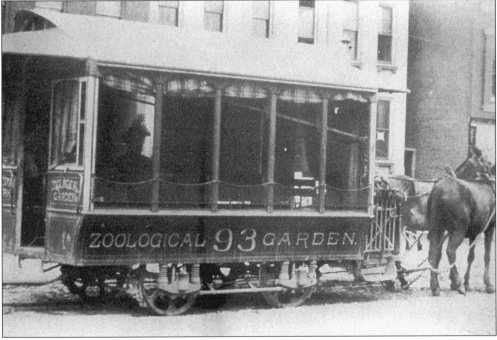

This streetcar marked "Zoo" was one of the public conveyances used by St. Louisans to visit their new zoo. At that time, the Zoo was a limited affair that contained few animals.

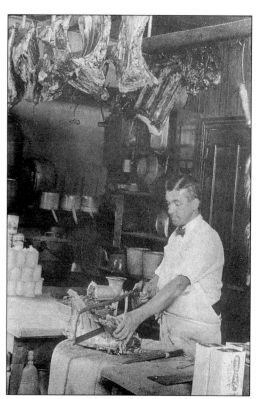

The Zoo Butcher Shop, shown here as in past years, is where various cuts of meat were prepared to feed the Zoo's hundreds of inhabitants.

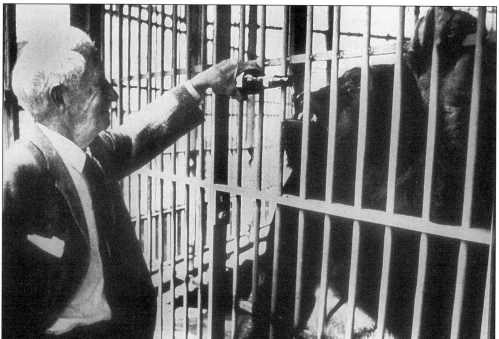

In 1926, at the suggestion of Director George Vierheller, or "Mr. Zoo," the Zoo began exhibition shows with chimps. Later they would use even larger animals. Here, Vierheller is pictured with Phil, a much-loved gorilla.

One of the Zoo's events involved the force-feeding of a snake called "Blondie."

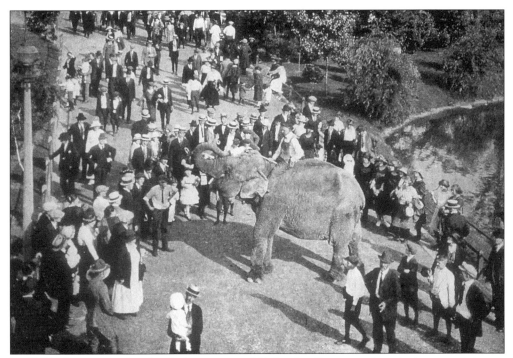

In 1917, this gentle female elephant, named "Miss Jim," was purchased. A state-of-the-art elephant house—funded by gifts of pennies from school children—was erected to be her home.

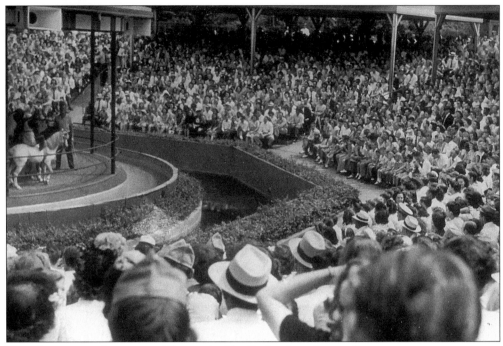

This chimpanzee show was avidly watched by St. Louis audiences for many years.

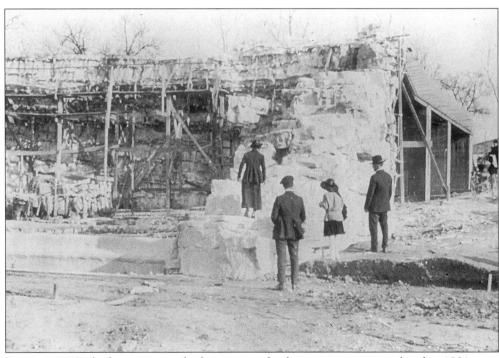

Begun in 1918, the bear pits were built in stages; the first section was completed in 1921.

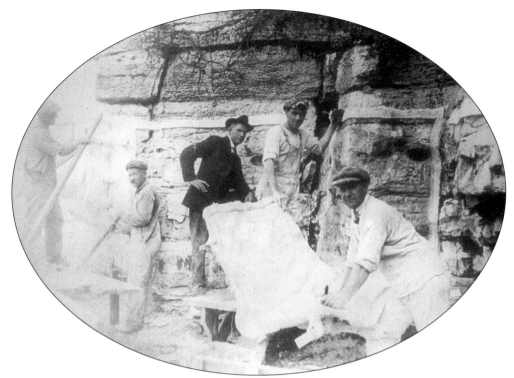

In this picture of the bear pit construction, workers create casts for concrete. The bear enclosures were built with concrete fashioned to resemble rock formations.

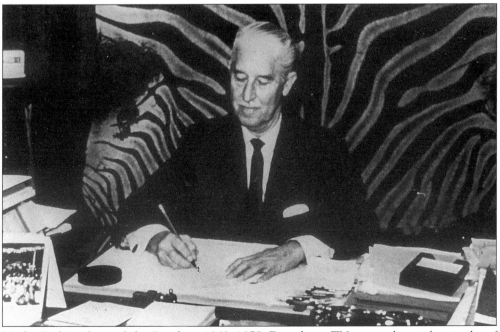

Marlin Perkins directed the Zoo from 1962–1970. Famed as a TV personality with episodes of adventures with wild and domestic animals, Perkins was beloved in St Louis.

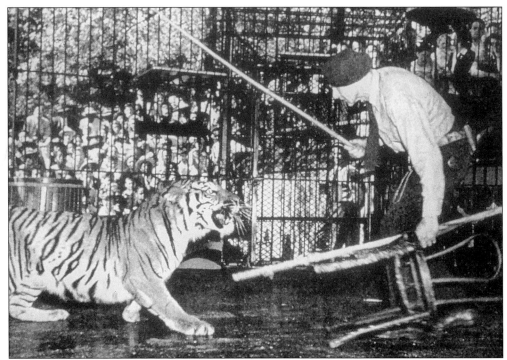

Another zoo performance that thrilled audiences was the Lion and Tiger Show in which a trainer faced and controlled various big cats.

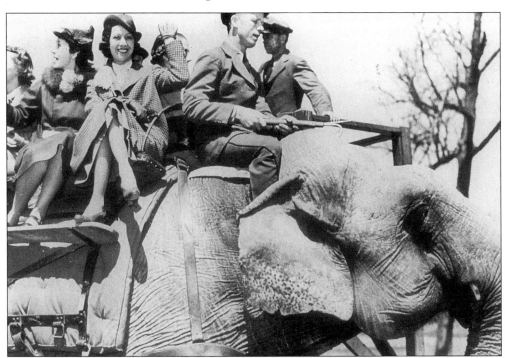

The tamed elephants were great favorites at the Zoo. Here, a young lady gleefully rode on the back of one of the gentle creatures.

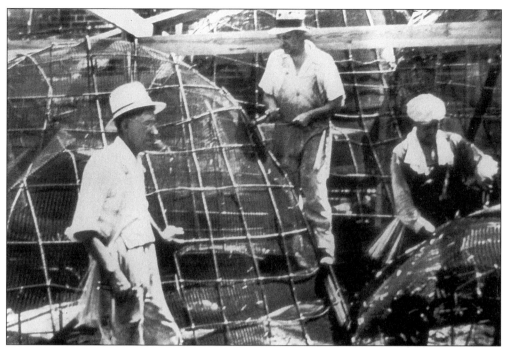

These ribbed antelope cages were built to comfortably house the animals. Here, laborers are pictured working through the first step in their construction.

In directing the zoo since 1982, Charles H. Hoessle has taken an imaginative and creative approach to the modern zoo. Under his guidance, many new habitats have been inaugurated to provide zoo animals with more natural, less restricted homes.

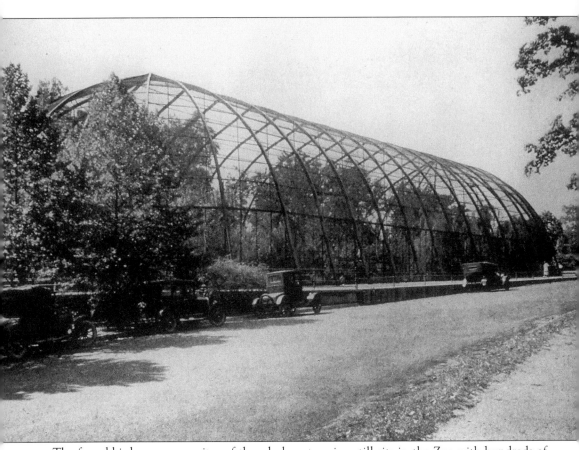

The famed bird cage, progenitor of the whole enterprise, still sits in the Zoo with hundreds of birds in attendance.

Five

PRIVATE STREETS AND NOTABLE PLACES

The Industrial Revolution swept through St.Louis without any environmental restrictions. As one of the nation's great manufacturing centers in the 1880s and 1890s, the city became a morass of smoke and unpleasant odor. To avoid such exposure, the new and enormously wealthy merchant class sought refuge in the West End. There, under the guiding hand of city engineer Julius Pitzman, they built elaborate homes on private places. These they named Portland Place, Westminster Place, Kingsbury Place, Washington Terrace, Westmoreland Place, and Vandeventer Place, among others. The grand houses they built were so outstanding that even today, they rival any group of lavish houses in the United States. Fortunately, a good number of them survived the city's decline during the last few decades.

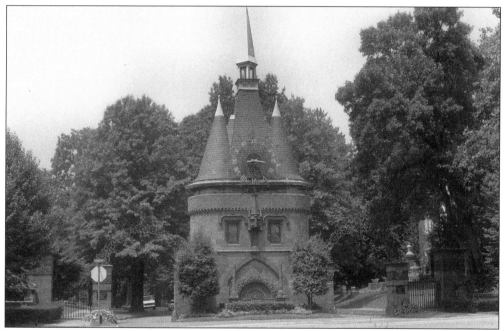

In order to provide security for the residents of these private streets, elaborate entrances with gatehouses were erected. The gatehouse at Washington Terrace is one such protective edifice. Its brilliant design included living quarters for its help.

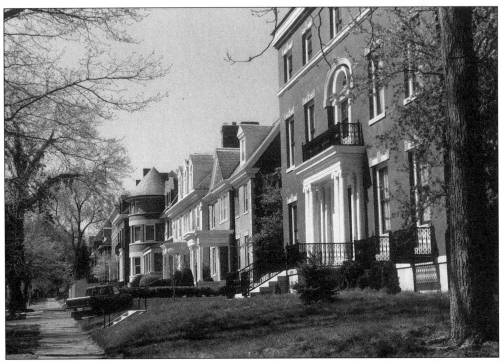

The Westminster Place, one of the cluster of private enclaves, is shown above with its array of elegant houses.

This apartment building, at 4633 Westminster Place, was once the home of celebrated playwright Tennessee Williams.

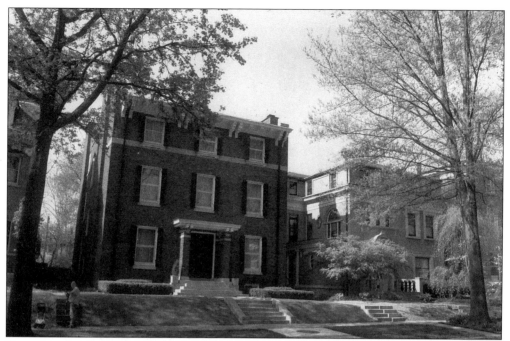

Several native St. Louisans who became famous in the literary world once lived in the West End; some even lived on the exclusive enclaves called Place. Here, at 4446 Westminster Place, was the former home of the poet T.S. Eliot.

This home, at 4232 McPherson, belonged to much maligned Kate Chopin. Although her frank novels created a storm of protest, she was defended by her St Louis associates.

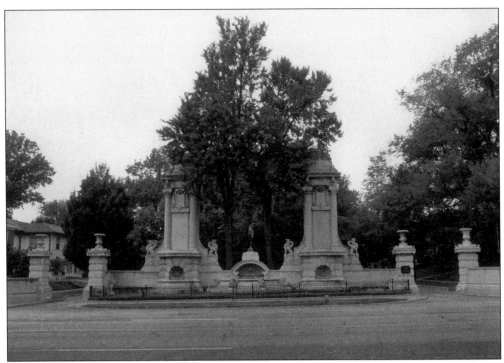

This stately, Beaux-Arts style entrance to Kingsbury Place was designed by the famous St. Louis architect, Tom A. Barnett.

This lovely home with its spacious front yard was the former home of the celebrated poet, Sara Teasdale. It can be found at 38 Kingsbury Place.

Portland and Westmoreland Places were considered the most desirable of the private places. Fortunately, most of the houses on these two streets have been substantially preserved. In the following section, we will deal with some of the major dwellings at these two addresses.

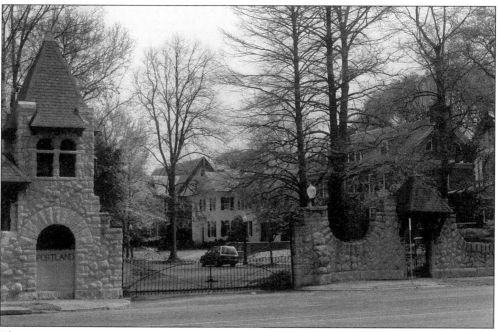

This ornate stone structure acts as the gatehouse/entrance for Portland Place. It was designed by another famous Victorian architect, Theodore Link.

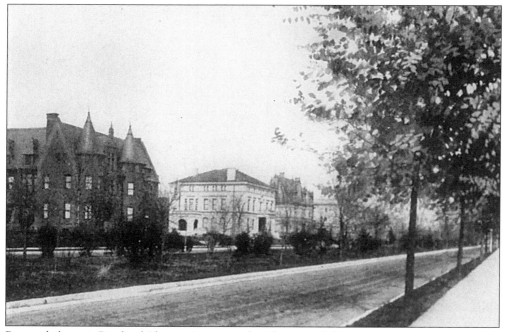

Pictured above is Portland Place as it appeared at the turn of the century.

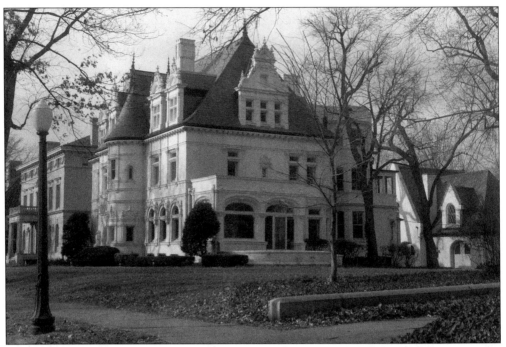

Created by the architect W. Albert Swayze in 1898, the French Renaissance chateau at 13 Portland Place is one of the most imposing of all the West End homes. Built with a white terra cotta exterior, it casts an aura of unsullied whiteness.

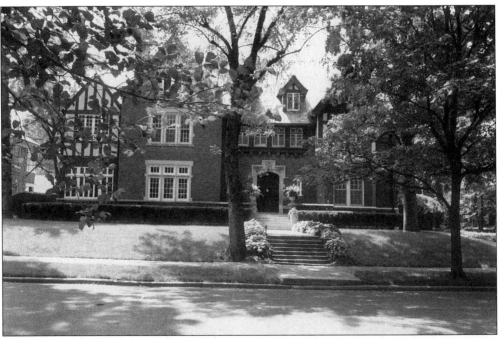

One of the elaborate houses erected on this palatial street is the present home of Rich and Joanna Nelson, located at 48 Portland Place. It was originally designed during 1907–1909 for Florence Lambert, of the pioneering aviation family.

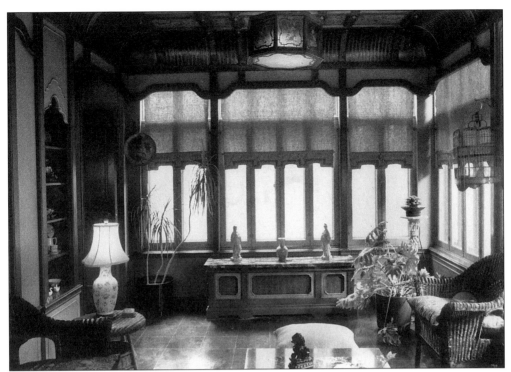

In a home bustling with art objects and other rich appointments, none can match the so-called Chinese Room, at 48 Portland, with its oriental decor.

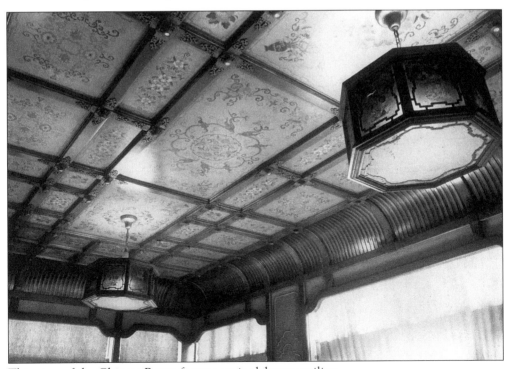

This view of the Chinese Room focuses on it elaborate ceiling.

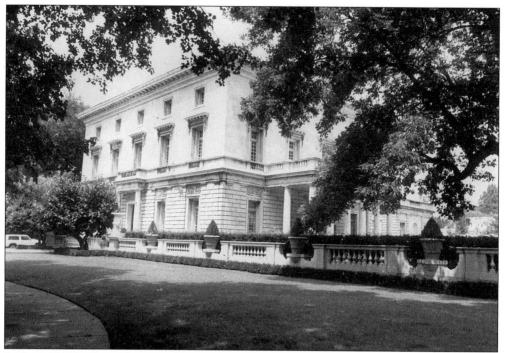

Built in 1910 by the architectural firm of Barnett, Haynes, and Barrett, this home at 1 Portland Place was first occupied by Edward Faust and Anna Busch Faust. Their marriage united two of the city's leading families.

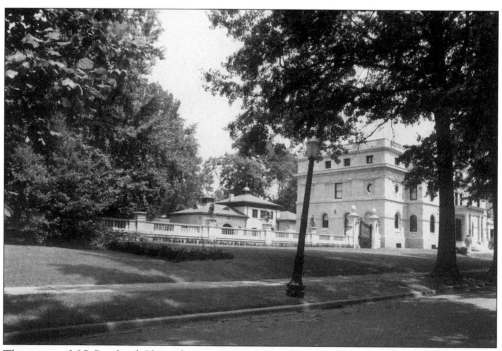

This view of 25 Portland Place demonstrates the elaborate extent of the mansion with its outside terraces, buildings, and stone fences.

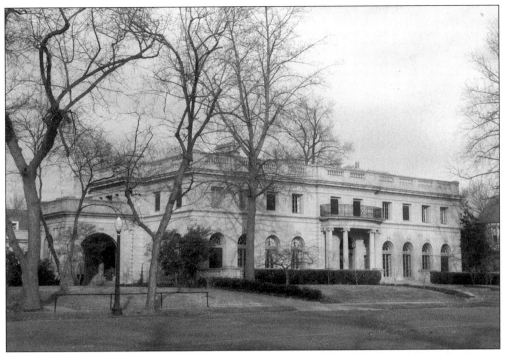

The stately portico entrance at 33 Portland Place was built by Claude and Dorothy Liggett Kilpatrick. The "Liggett" reminds us that St. Louis was once a tobacco center.

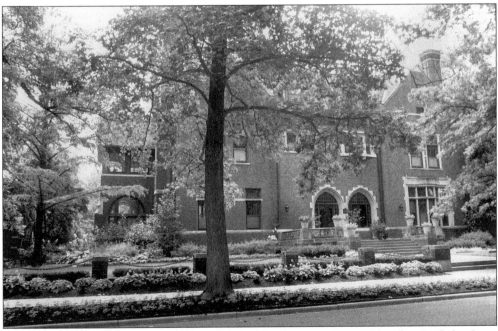

Thirty-eight Portland Place was built in 1905 by the famous architect Theodore Link for Oscar and Irene Johnson, of the International Shoe Company. This stately building emphasizes the forward thrust of its arched porch and side windows to its landscaped front yard, filled with shrubs and flowers.

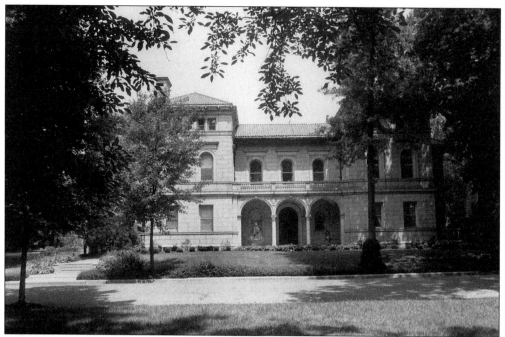

Built in July 1892, the Italian Renaissance palazzo at 17 Westmoreland was first inhabited by John and Marie Davis. In 1986, it was purchased by the late Leon Strauss and his wife Mary, the highly committed restorers of the Fox Theatre.

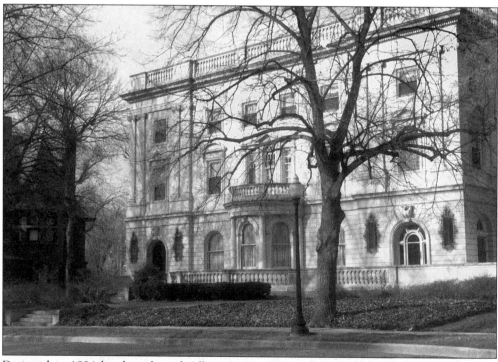

Designed in 1894 by the talented Albert Swayze, One Westmoreland emphasized the wide terrace that fronts the house.

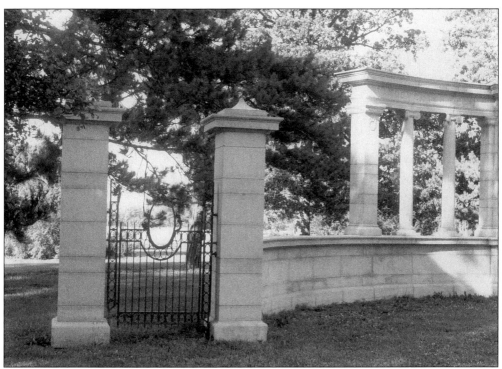

Perhaps the grandest street of the Edwardian era was the private complex called Vandeventer Place. In the '60s, the entire area was torn down to make way for a hospital. This elaborate gate was moved to Forest Park where it permanently rests.

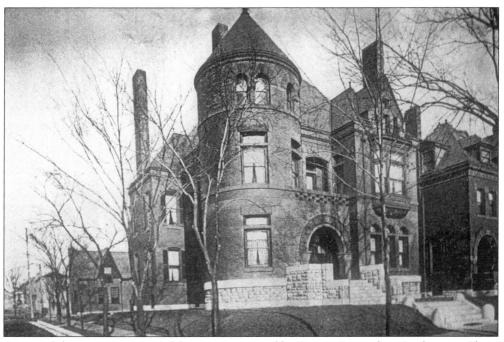

A turn-of-the-century picture of the mansion owned by George Barnard in Vandeventer Place.

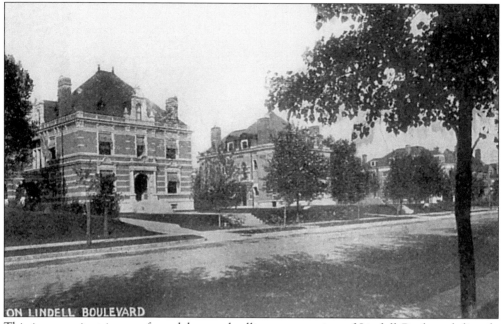

ON LINDELL BOULEVARD

This is an ancient image of an elaborate dwelling on a section of Lindell Boulevard directly across from Forest Park. Known as the Lindell Strip, this area became a popular location to build enormous mansions because of its proximity to the Park.

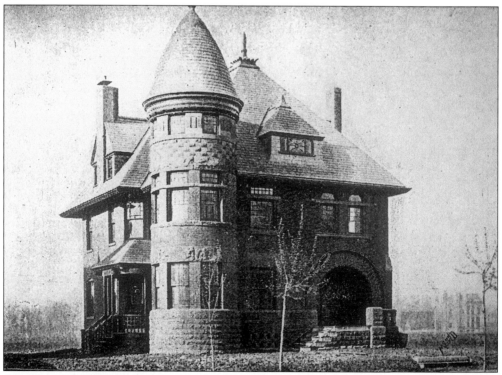

An old mansion that occupied one segment of the Lindell Strip at the turn of the century is illustrated here.

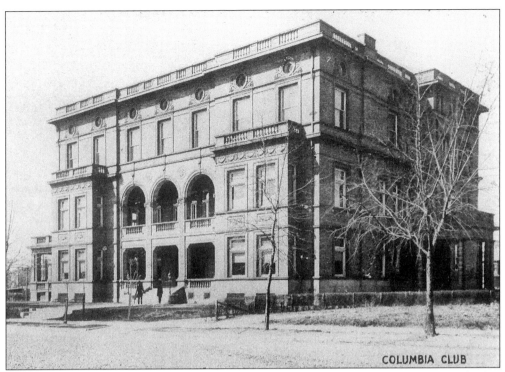

The Columbian Club, a Jewish social and fraternal club, was destroyed by fire early in the last century. It once thrived as a Jewish-only gathering center. Since they weren't permitted in various WASP clubs in the city, the Jewish community created their own club.

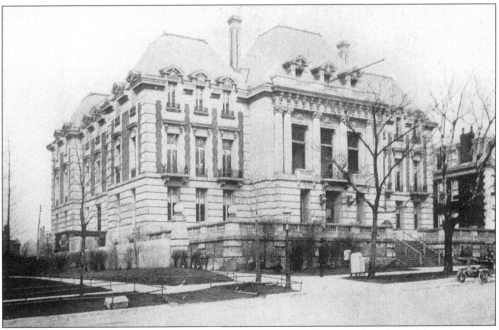

The elegant St. Louis Club on Lindell was for many years the Woolworth Building. It is now owned by St. Louis University, whose complex of buildings stands directly across the street.

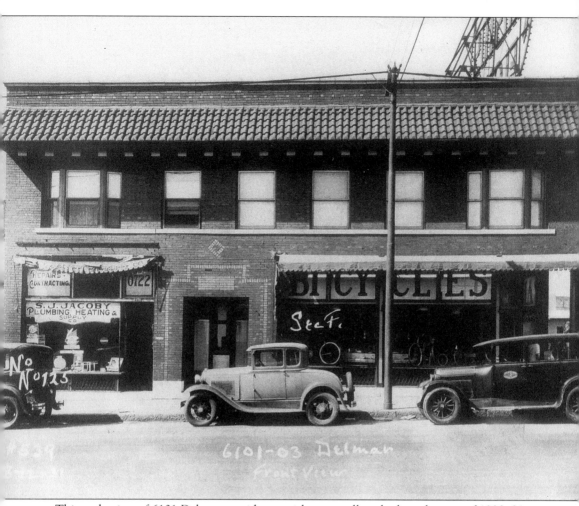

This early view of 6101 Delmar provides us with an excellent look at the cars of 1930–31.

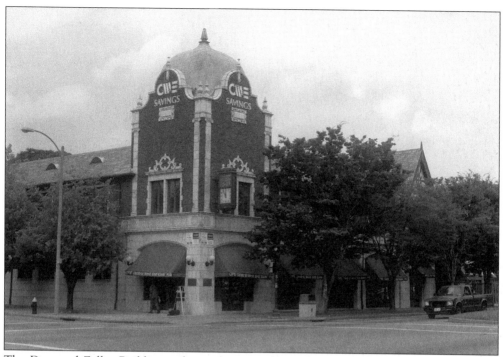

The Dorr and Zeller Building, a business center, bears the initials CWE on its upper floor, announcing to the world that it is positively part of the Central West End.

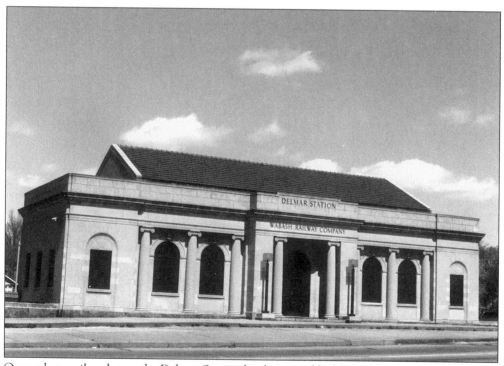

Once a busy railroad stop, the Delmar Station has been used by businesses in recent years. Some say that President Truman once held a whistle-stop political rally from its platform.

The major problems of maintaining sewerage and its run-off in the West End were not entirely solved until 1954 when the MSD (Metropolitan Sewer District) was established. Various earlier sewer authorities had to deal with the creation of new sewers and the vulnerability of the ground in which their ditches were dug. The following shots illustrate their wins and woes.

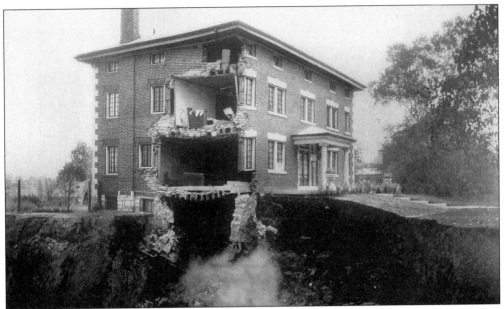

The collapse of the corner of the Canfield residence at 5955 Lindell in 1930 was a project that the engineers had to correct.

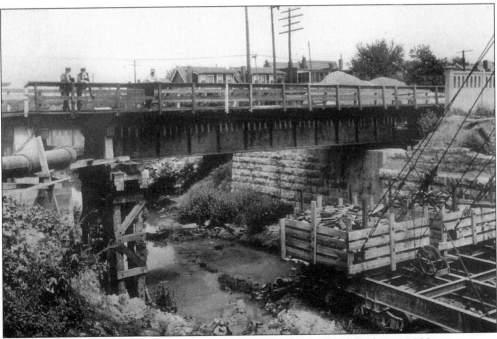

River des Peres is pictured above as it flows under the Rock Island Bridge in 1930.

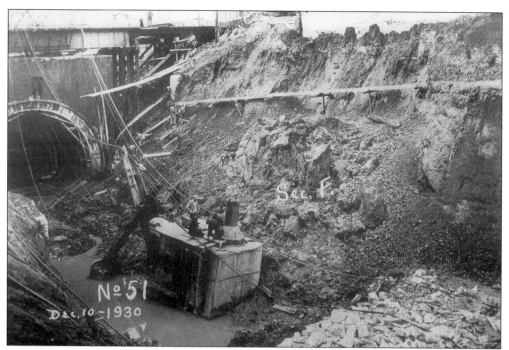

This slide, which happened in December of 1930 on Pershing Avenue, was another obstacle for the engineers.

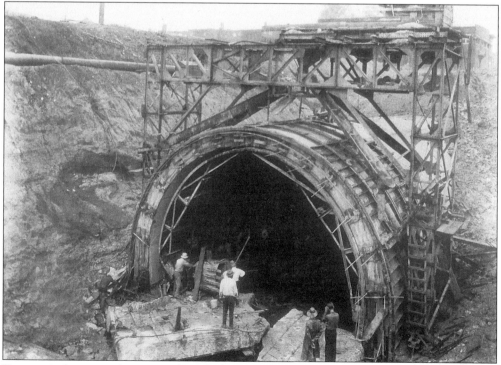

Progress is shown on the giant culvert looking north on Delmar on August 5, 1931.

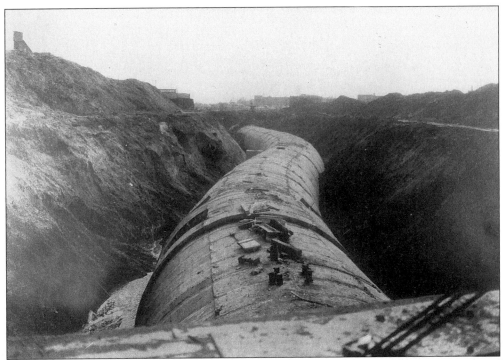

This shot, taken February 10, 1932, shows the engineering at the completed sewer just east of Skinker.

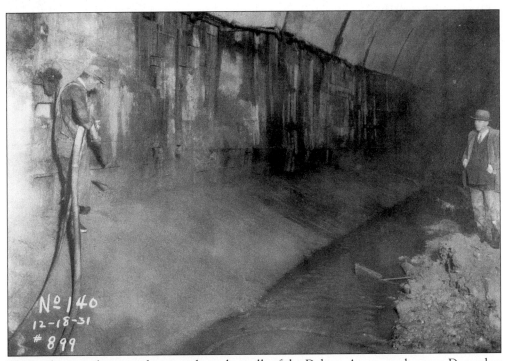

Nº 140
12-18-31
899

This underground picture shows work on the walls of the Delmar Avenue culvert on December 18, 1931.

The Catholic Office of Special Education, at 4472 Lindell, maintains its residence in this historical old building.

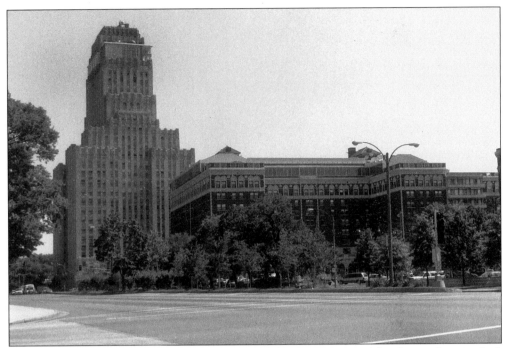

The Park Plaza and Chase Hotel remains one of the most esteemed locales in the city. Left vacant during St. Louis' decline, the Chase Hotel complex has now bounced back and has been restored to a renewed beauty.

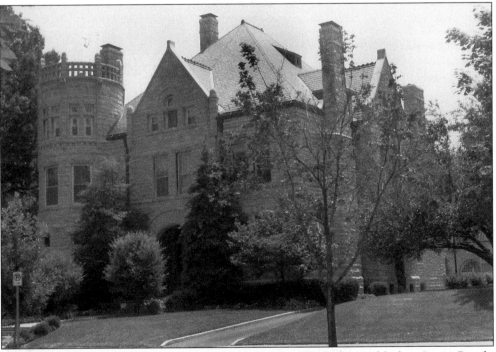

This Lindell Boulevard mansion is the present home of Catholic Archbishop Justin Regali. Pope John Paul II stayed here when he visited the city early in the year 1999.

Six

SCHOOLS OF THE
WEST END

In keeping with their social status, the wealthy parents who lived in these private places sent their children to exclusive nearby private schools. Foremost of these were the Mary Institute for Girls and the Smith Academy for Boys. Later, when most of the affluent flocked further west to the county, the Mary Institute moved from its West End address to suburban Ladue, where it still remains. The Smith Academy closed.
In time, less wealthy folks sent their children to the public schools that began to appear in the West End. Among these were the Hamilton Schools, of which there were several branches: the Rock Spring, Adams, and Marquette lower schools; and Central, Stix, and Soldan High. Those who remained living on such streets as Westmoreland and Portland Place sent their offspring either to Soldan, which was a rather fashionable school in its day, or to McKinley High, which was located farther east in the city. The following photos shown below attempt to capture the lives of the students and their teachers. Most represent the West End in its youth and vigor. Today, the West End has a goodly number of private schools, while its public schools have been refurbished and one even acts as a "magnet" school.

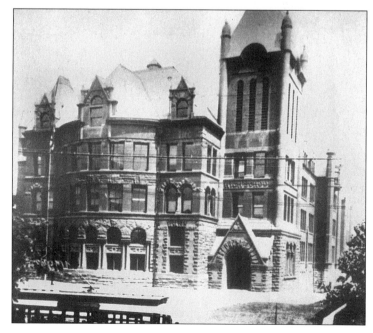

This is old Central High as it appeared near the turn of the century. While modern standards might find this building to look too much like a "gingerbread" house, it was still quite striking in its day. It was located then at Grand and Finey.

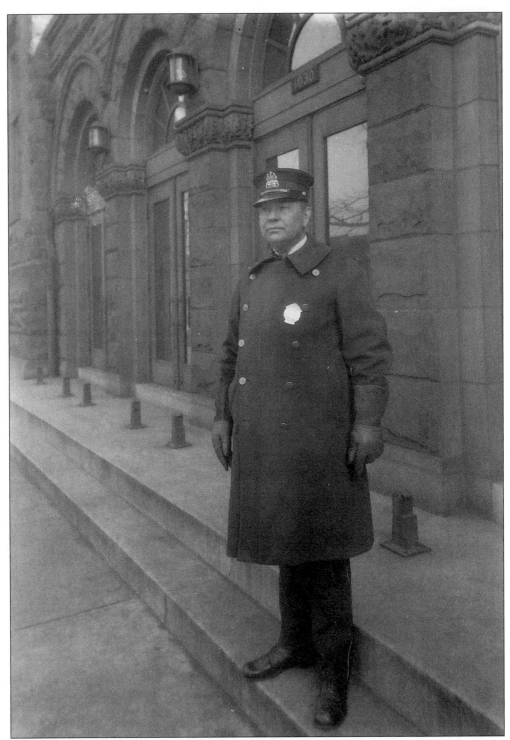

Standing firmly at his post is the guardian spirit of the lads and lasses attending Central High. A traffic officer in this 1925 photo, Mr. Fehlig stands in front of the school's over-stylized front entrance.

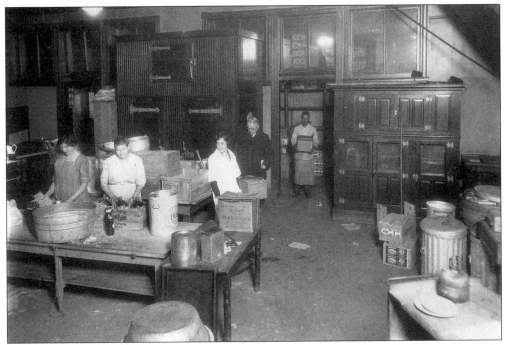

Here is a 1926 shot of Central High's enormous kitchen. Cooks and their helpers appear to be packing kitchen equipment.

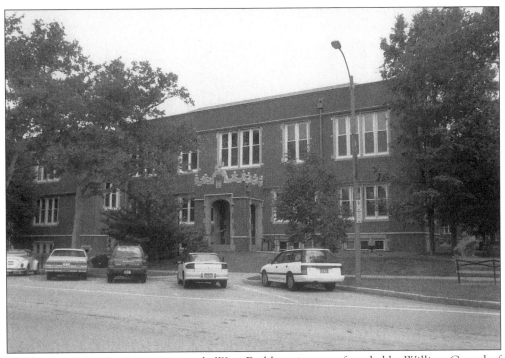

The historic Mary Institute, at its early West End location, was founded by William Greenleaf Eliot, the grandfather of the poet T.S. Eliot. A Unitarian minister, Greenleaf named the school after a daughter called Mary, who died at 17.

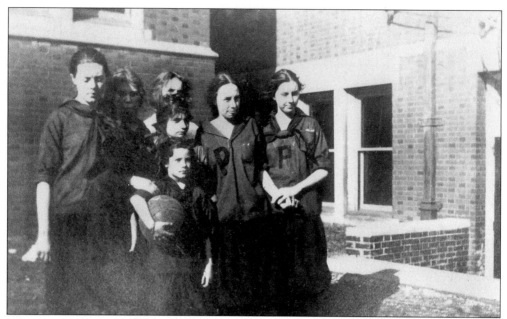

Here an athletic team of Mary girls lined up with a young mascot holding a treasured ball. This progressive school emphasized sports.

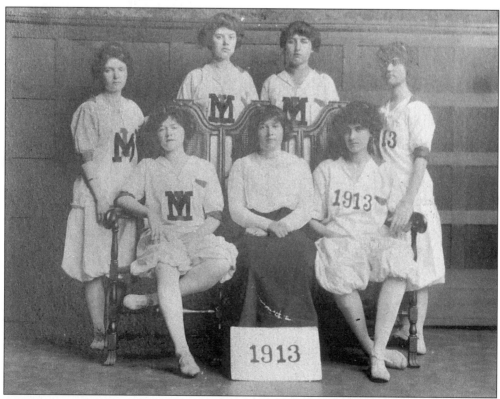

Another Mary Institute athletic team is pictured here in 1913, with both the players and their coach decked out in ballooning knickers.

Here again we see not a "St. Louis Gothic shot," but rather three young Mary girls in their contemporary clothing.

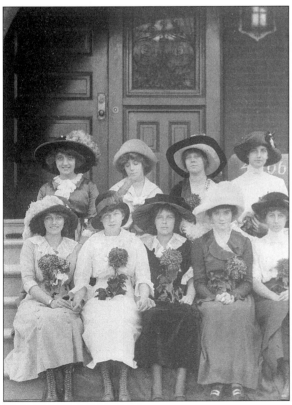

Mary alumnae made quite a fashion statement by posing in these monstrous hats. Among these women may be the sisters of the poet Eliot, three of whom went to Mary Institute.

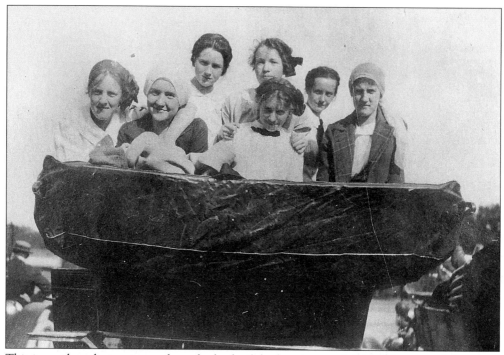

This is another alumnae pose, from the back of the latest, most fashionable automobile.

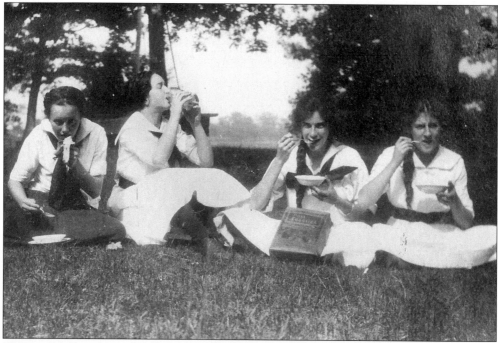

This is another photo documenting the lives and times of Mary Institute girls. Here the automobile occupants are picnicking and enjoying life with style.

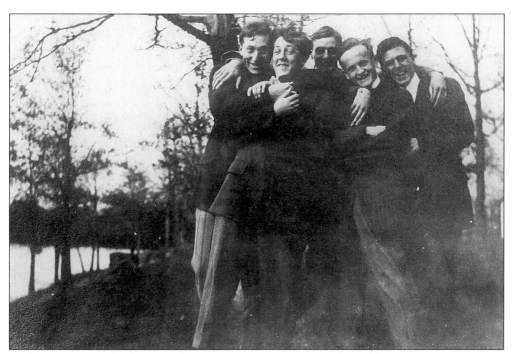

This photo could easily be called "Mary's boys"; these are the young men who courted the young ladies of the Institute.

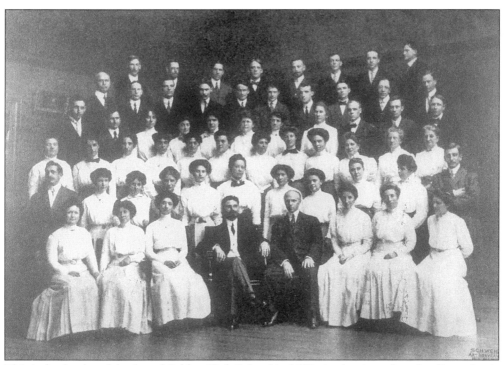

This is the faculty of the famed Soldan High School in 1909. At the time, the school's academic standards were remarkably high.

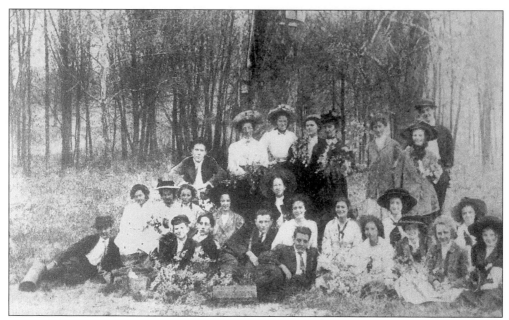

Soldan also possessed a Botanical Club, whose members are shown here in this 1909 photograph.

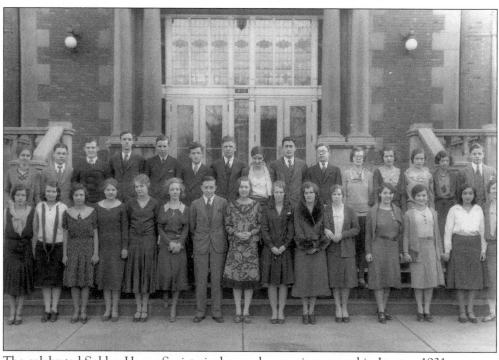

The celebrated Soldan Honor Society is shown above as it appeared in January 1931.

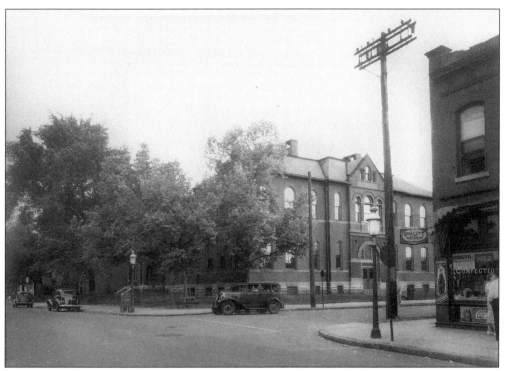

The Adams School at 1311 Tower Grove is shown in this June 1937 image.

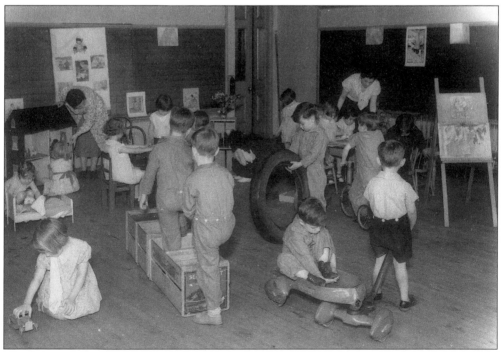

The Adams School also had a kindergarten section. Here is a group of young people in May of 1934, hard at work, busying themselves with various toys.

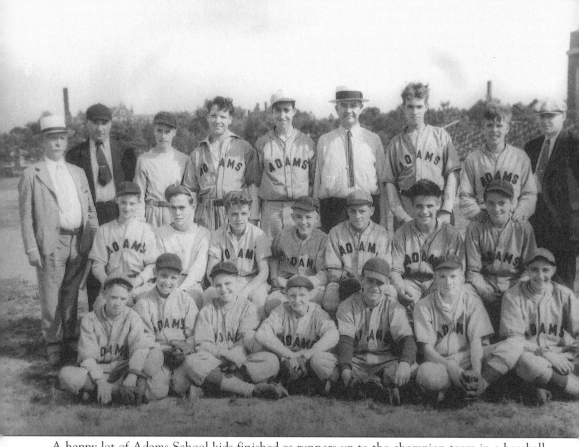

A happy lot of Adams School kids finished as runners-up to the champion team in a baseball competition of lower grade schools in June 1934.

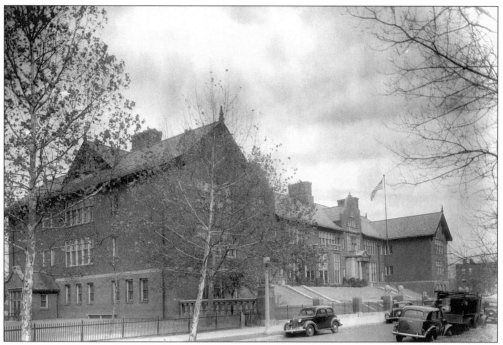

This is the handsome Hamilton School, at 5819 Westminster Place, as it appeared in 1938. It was part of the system of "Hamilton Schools" spread through the West End.

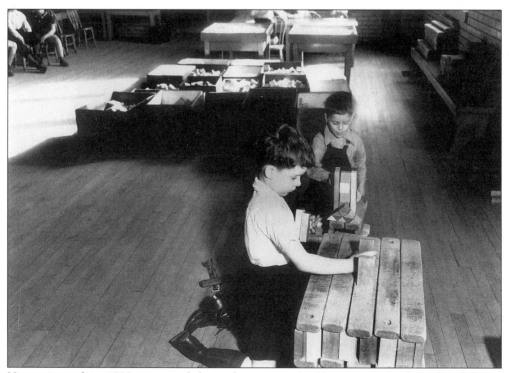

Here, pictured in 1938, is one of the early projects the Hamilton School employed for its youngest students—kids working with building blocks.

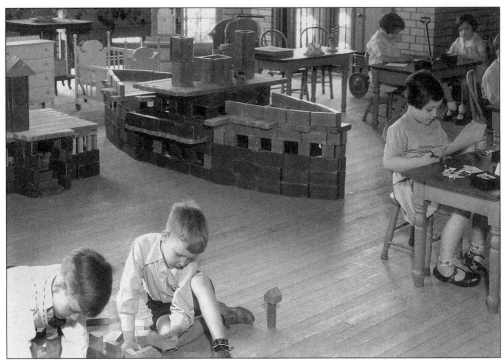

Here is another view of the youngsters at the Hamilton School, busy with their blocks in 1932.

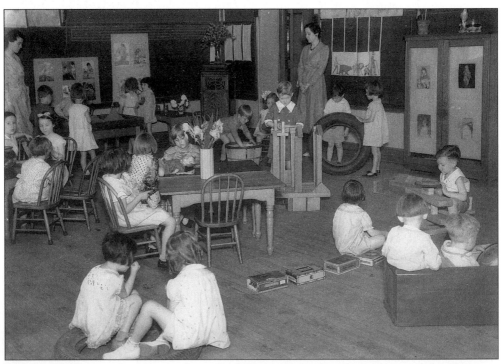

The preschool at another area academy, Rock Spring School, is shown here in May 1934.

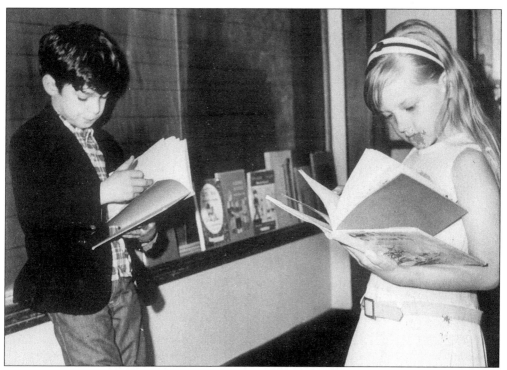

Two intense "baby" readers at the Rock Spring School looked over some available books.

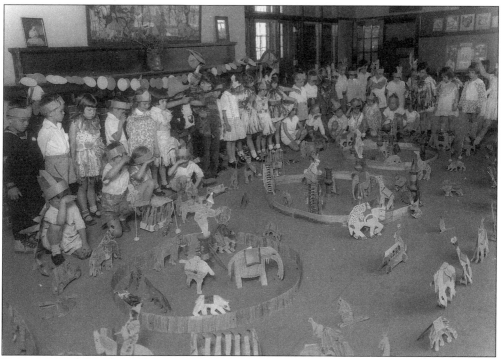

Here is an early hands-on project: a miniature circus put together by a kindergarten class at the Stix School, another West End member. The picture is dated May 1930.

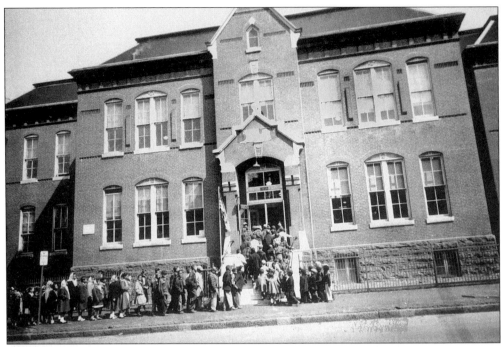

Pictured here is a group photo of students entering their colored school with their teachers. Its staff consisted mostly of African-American teachers.

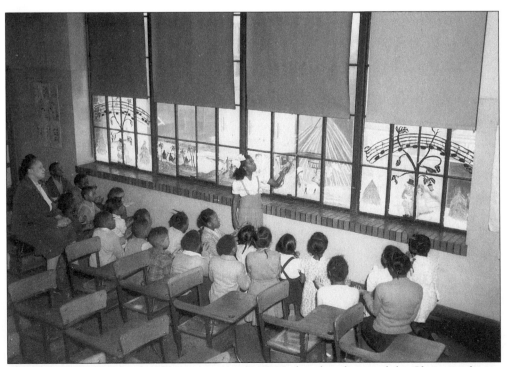

This is the Lincoln School at Christmas time. In 1946, this class discussed the Christmas figures drawn in the window.

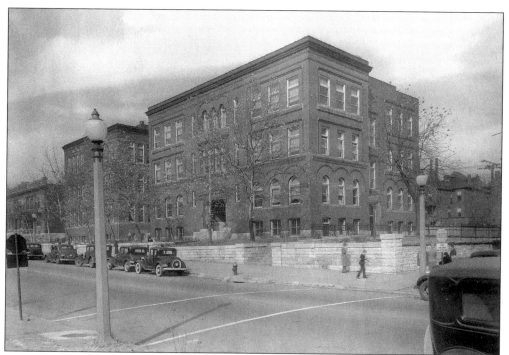

This is a picture of another West End school, the Marquette School at 4015 McPherson, in May 1938.

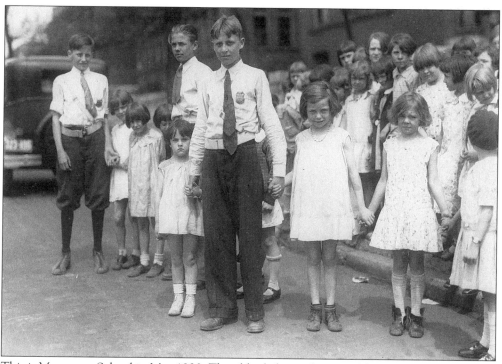

This is Marquette School in May 1930. The older lads acted as patrol boys for the young. "Your hand in mine" was the slogan of these guardians in assisting their young wards across the street.

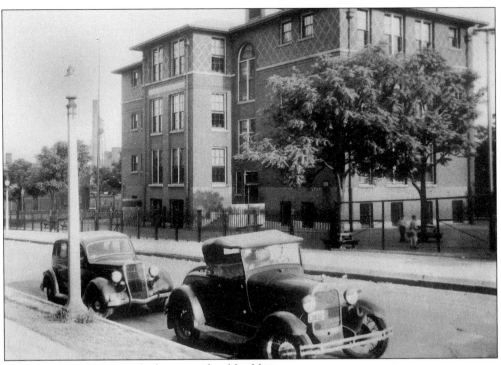

These vintage cars are parked near a school building.

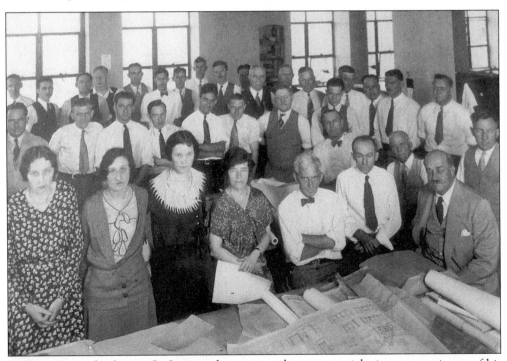

William Ittner, the famous St. Louis architect, is at the extreme right in a group picture of his working staff. Celebrated for his school building designs, he once served as the commissioner of schools.

Seven

THE UNIVERSITIES

The two principal institutions in the West End are major universities, St. Louis University (SLU) and Washington University. SLU, which is currently undergoing a major rebuilding and landscaping renaissance under the inspired leadership of Father Lawrence Biondi, has always acted as an anchor for the surrounding area of a dozen city blocks called Midtown. Once thriving with theatres, professional offices and clubs, shops, and restaurants of all kinds, Midtown was sorely neglected and fell nearly vacant over time. Under the guidance of Father Paul Reinert and Father Biondi, the area has been revitalized and has regained some of its old spirit.

The histories of Washington and SLU go back as far as the early 19th century. Both now have hospitals, graduate schools, research centers, and faculty that have caused recent polls to mark them as two of the most important educational centers in the county.

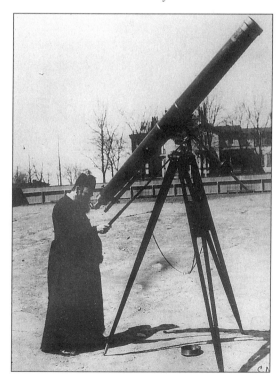

Through this well-worn telescope, Jesuit Father Charles Charropin observed a lunar eclipse in the 1890s.

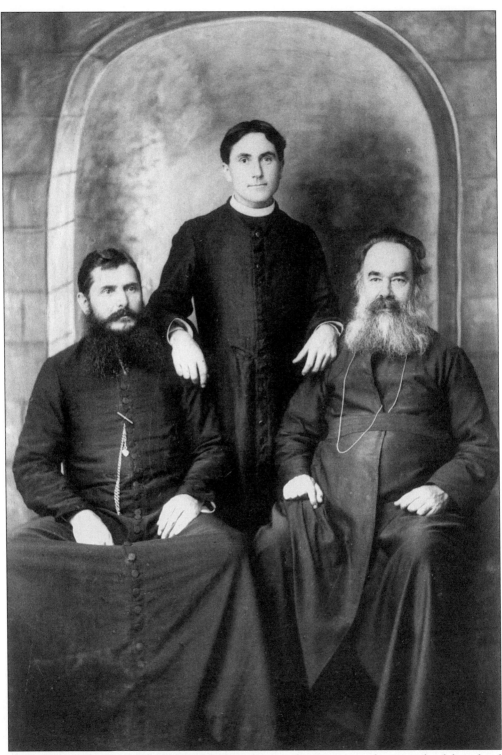

Father Charropin (on the right) posed here with two other Jesuits on the grounds of the school that is considered the oldest university west of the Mississippi.

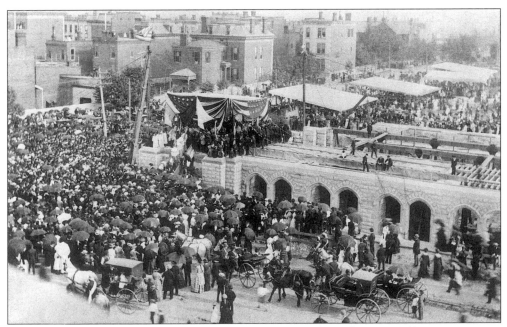

In this enormous dedication ceremony for the college church, the cornerstone was laid for St. Francis Xavier (the college church as it is known in June 1884).

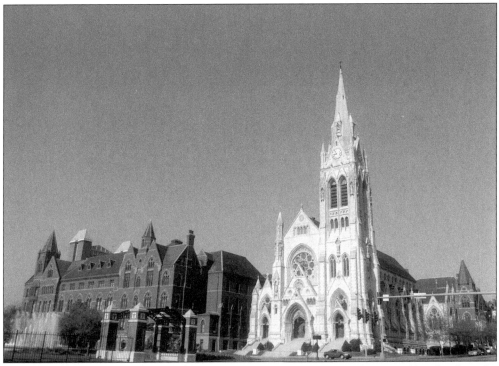

Dubourg Hall, an old structure in the St. Louis University complex, is still utilized as the school's administration center. Here it is pictured next to the college church.

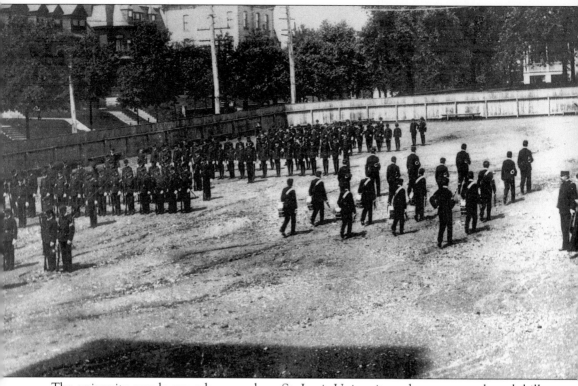

The university parade grounds were where St. Louis University cadets once conducted drills back in 1894–5.

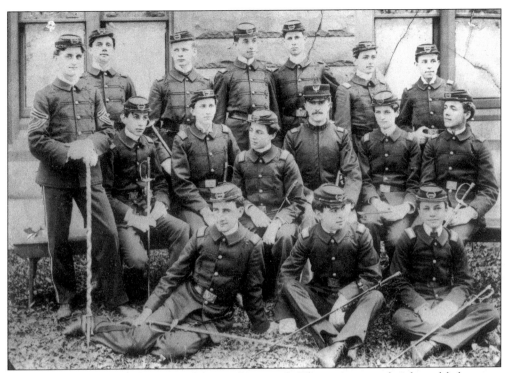

Here, the university cadets pose for a group photograph. The picture was dated roughly between 1896–1897.

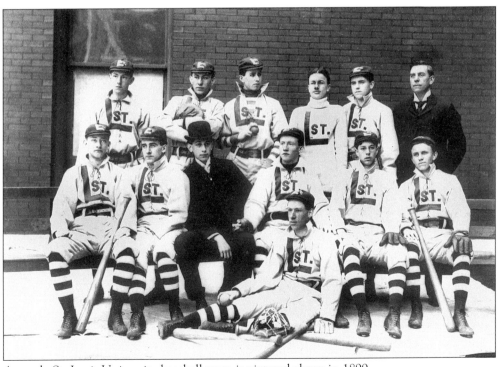

An early St. Louis University baseball team is pictured above in 1899.

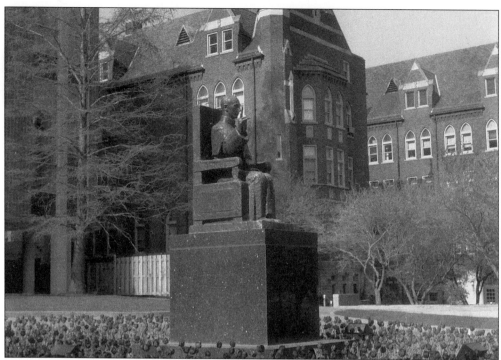

This statue of Pope Pius XII stands faithfully before the library that bears his name. The library contains microfilm copies of most of the contents of the famed Vatican Library.

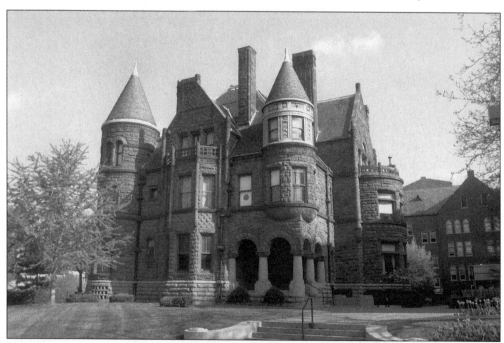

This Romanesque structure, built by the Victorian merchant C.S. Cupples, is now used as a university museum. In its lower section is the McNamee Gallery, named after one of the men who saved the mansion from destruction, Father Maurice McNamee, S.J.

Current SLU President Lawrence Biondi, S.J., has reshaped the university in an inspired manner. Through a series of major building programs, he has managed to create a campus which is truly a triumph. In a real sense, he has been a catalyst for the rebuilding of St. Louis.

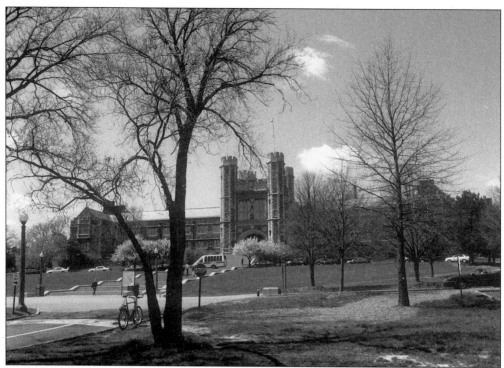

Here is a present-day picture of Washington University with its long tree-lined walk to Brookings Hall.

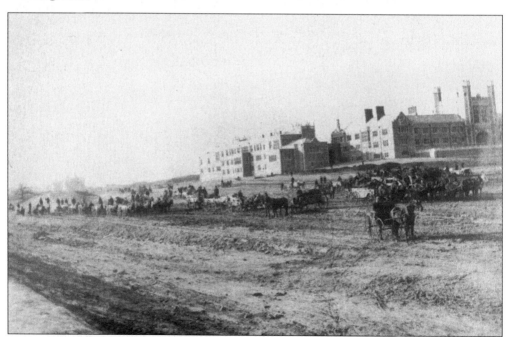

This picture shows Washington University at the turn of the century, with Busch Hall and University Hall looming in the background. Workers here are preparing the ground for further university buildings.

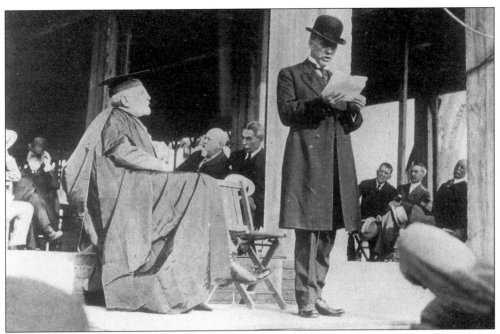

Robert S. Brookings, a great financial patron of the young university, is seen here in his ceremonial robes in 1913.

Here is Brookings with a Washington University Chancellor and U.S. Vice President Charles B. Dawes at commencement in 1927.

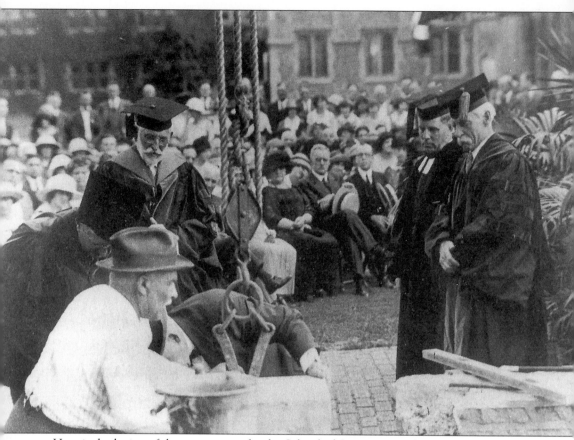

Here is the laying of the cornerstone for the School of Commerce and Finance. Brookings and Chancellor Hall presided over the laying in 1923.

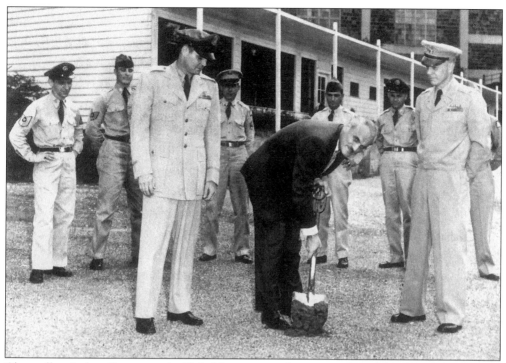

Chancellor Arthur Compton, the Nobel Laureate, is shown at a ground-breaking ceremony for a ROTC building in 1951.

Here is a 1915 image of the new buildings of Washington University Medical School.

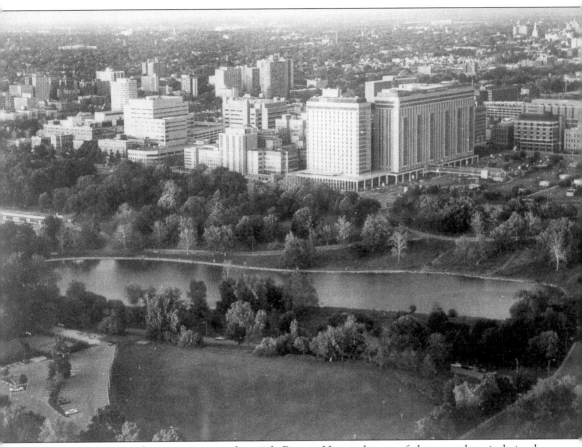

This is the complex as it exists today with Barnes Hospital, one of the great hospitals in the country, displayed as a backdrop to Forest Park.

Eight
HISTORIC CHURCHES

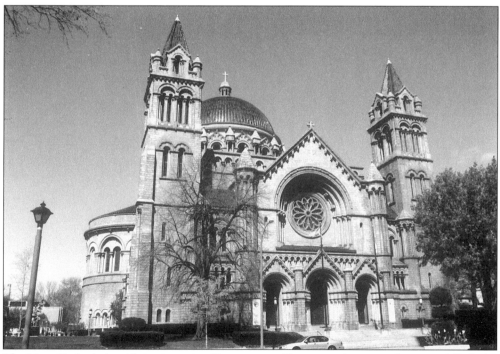

The New Cathedral, with its imposing Romanesque-Byzantine design, is the seat of Catholic pastoral authority and the church of the bishops and archbishops of St. Louis. An artistic triumph, the church's interior is full of mosaics without parallel in the Christian world depicting the works of various holy men.

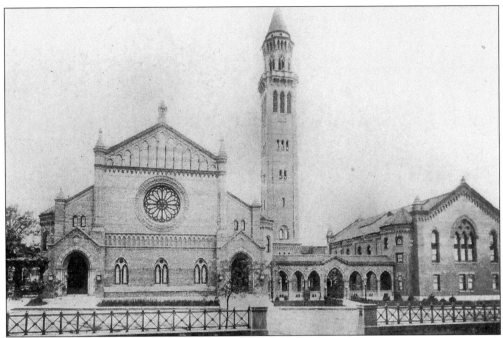

The Second Baptist Church at Kingshighway and Washington was designed in a Medieval-Renaissance style, with rose window and steeple reflecting its major influences.

On a stretch of Kingshighway, from Lindell to beyond Washington Avenues, was a group of churches that represent several faiths. Among these were the Temple Israel, St. John's Methodist, the Tuscan Temple, and the First Church of Christ, Scientist. Nearby, on Washington Boulevard, stood the Second Baptist Church. This cluster of buildings became known as the "Holy Corners" or "Piety Hill."

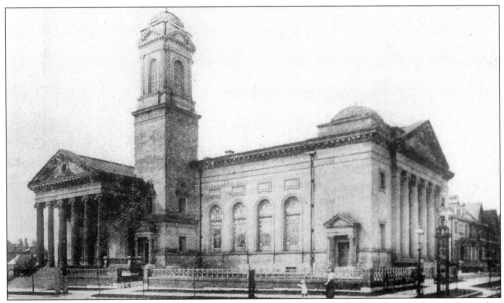

With its classical columns and bell tower, the Theodore Link-designed St. John's Methodist Church was a blend of Romanesque, Gothic, and Classical styles.

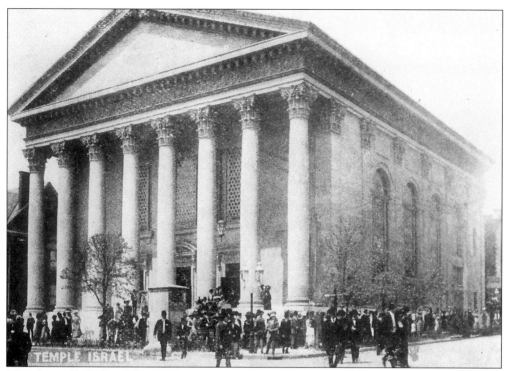

This classically fashioned temple, with its Corinthian columns, was one of the original buildings on the corner. Initially the Temple Israel, it is now the Angelic Temple of Deliverance.

The First Church of Christ, Scientist, another member of the Corner, at 477 North Kingshighway, was designed in 1903. Although its general style is Classical, it also shows the influences of the Arts and Crafts movement that was sweeping England.

The Tuscan Temple, one of the original members of the Holy Corners, was designed in its Classical manner in 1907–1908 by architect Albert Groves.

The noted Masonic Temple stands on Lindell as it approaches Grand. An historic landmark, built to ape the Classical temples, it is directly across from St. Louis University.

The famous Moolah Temple of the Mystic Shrine was designed in a Moorish and Arabic style and erected in 1912. Although it lay vacant for many years, it has now been bought up by developers who wish to convert it into a business office building.

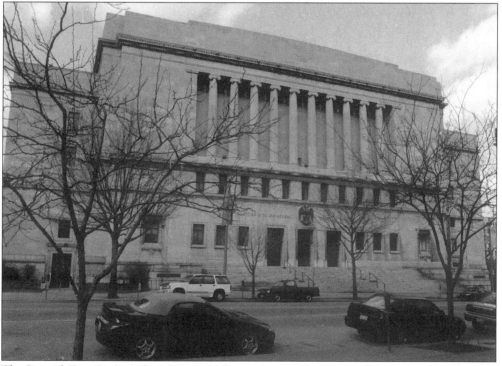

The Scottish Rite Cathedral, at 3633 Lindell, was designed by William Ittner, the school builder. Its enormous structure contains a magnificent auditorium that seats three-thousand people.

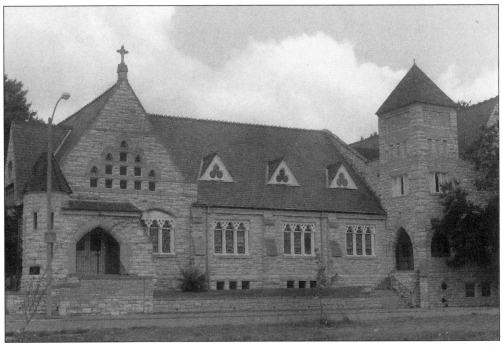

St. Stephen Lutheran is another West End edifice. It was built to resemble an English parish church.

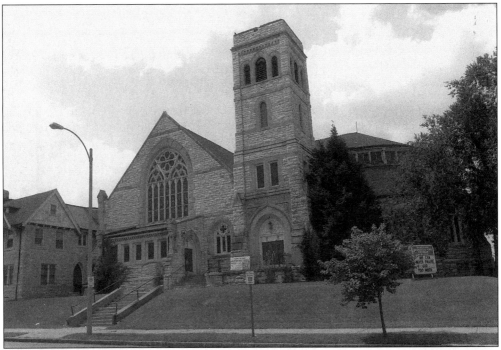

Scruggs Memorial Christina Methodist Episcopal Church, on Cook Avenue, was built in 1884. One of its fanciful stained-glass windows contains a portrait of Richard Scruggs, a local department store owner.

This photograph shows the Brith Sholom Congregation Synagogue at 6166 Delmar. The building is now occupied by the Oliver Baptist Church.

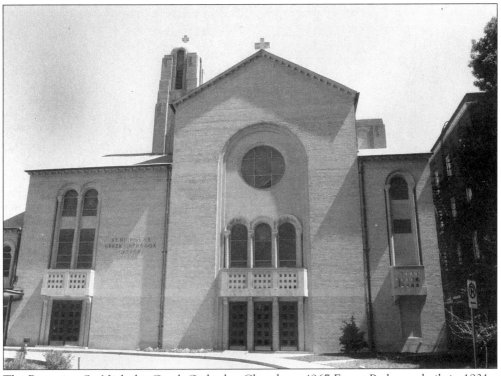

The Byzantine St. Nicholas Greek Orthodox Church, at 4967 Forest Park, was built in 1931.

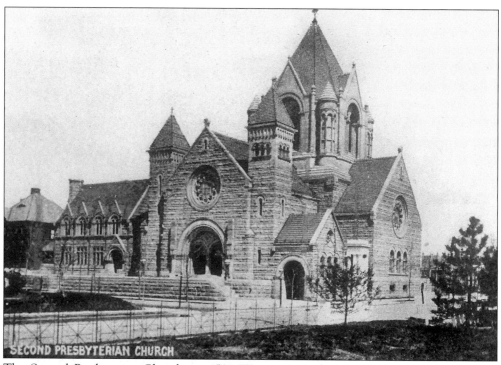

The Second Presbyterian Church, at 4501 Westminster Place, wears its rose windows and Medieval steeples with grace and authority. This photo was taken near the turn-of-the-century.

This photo shows one of the more striking features of Midtown, the Third Baptist Church on the corner of Grand and Washington.

Another vital member of the Midtown area is the St. Alphonsus Liquori Roman Catholic Church. Known as the "rock church," it has a dynamic new pastor and congregation.

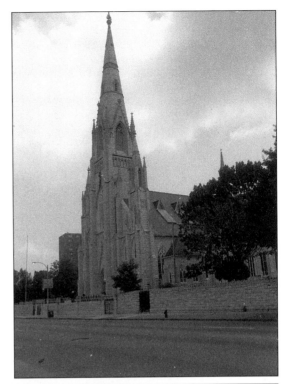

Trinity Episcopal, at Euclid and Washington, is shown below. Because of its determination to remain at its present site despite the city's years of decline, it has been a stalwart in the restoration of the West End.

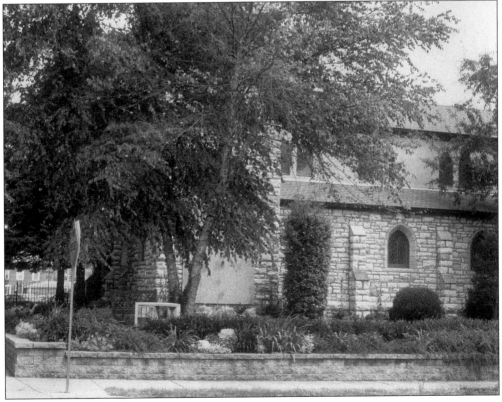

In the years between 1904 and 1907, a group of churches that came to be called the "Union Boulevard Collection" were erected on the 700–800 block of Union Boulevard. These included Union Christian, Pilgrim Congregational, and Church of the Messiah Unitarian. In 1913, they were joined by Westminster Presbyterian.

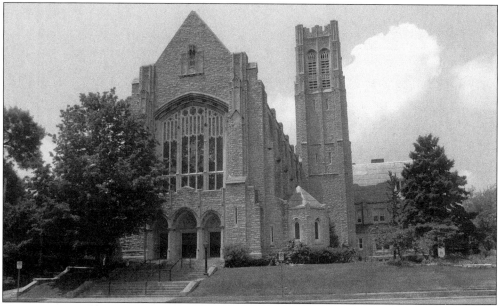

Built in 1913, Westminster Presbyterian Church is one of the long-standing historic churches in the district.

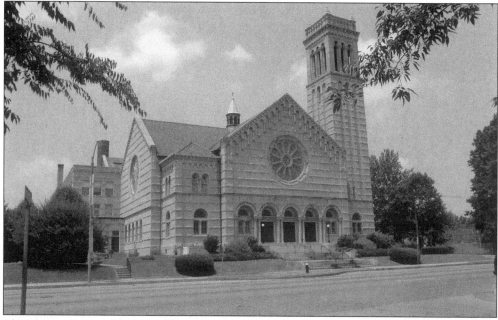

The Union Avenue Christian Church, at 733 Union, was started as a small chapel in 1904. Its main building was completed in 1908.

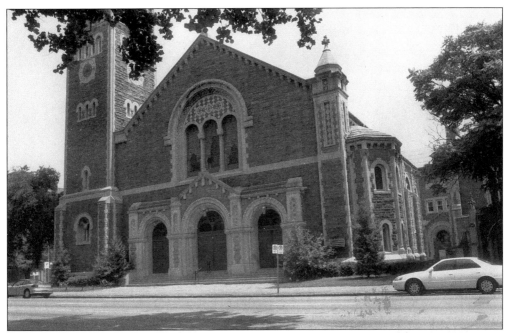

The Pilgrim Congregational Church was erected to commemorate the Congregational English immigrants who landed at Plymouth, Massachusetts, in 1620. The church was completed in 1906.

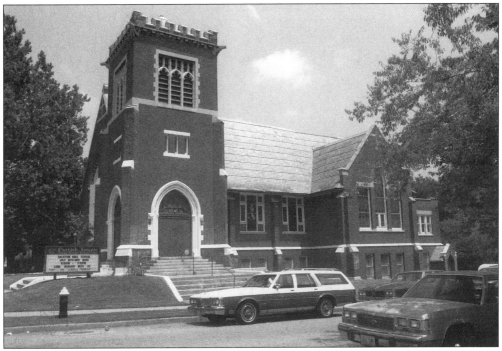

The modest Parish Temple Christian Methodist Episcopal Church was aided financially by Henry W. Eliot, T.S. Eliot's father. The first congregation of this church was led by T.S. Eliot's grandfather, William Greenleaf Eliot.

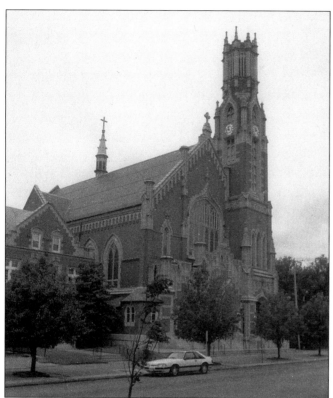

The highly ornamented Tudor and Gothic St Rock's Church was named after a sainted layman.

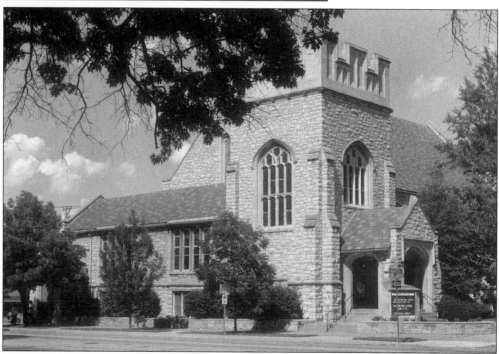

The New Cote Brillante Church of God, at Washington and Skinker, was designed by the famed architect and school commissioner William B. Ittner.

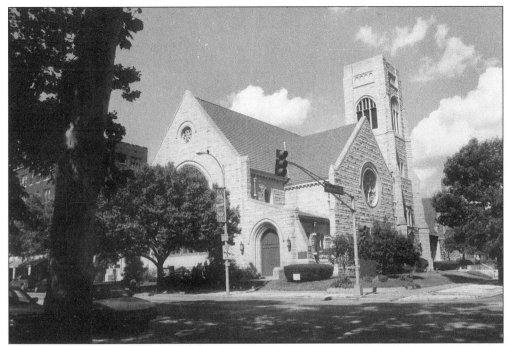

Designed by Theodore Link, the Grace Methodist Church, at Skinker and Waterman, is one of the few stone churches in the city "built stone by stone in its site." Its interior boasts hand-carved pews of black birch.

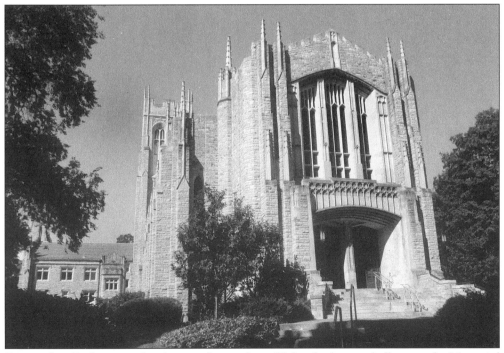

Designed in Gothic revival style, complete with an 85-foot high stone bell tower, the Memorial Presbyterian Church was started in 1925 and completed in 1931.

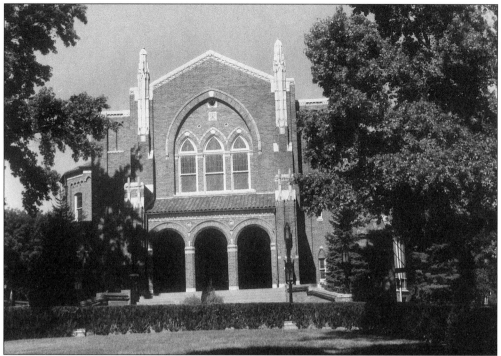

The Eighth Church of Christ, Scientist, at 6221 Alexander Drive at Wydown, was completed in 1929. It was fashioned in a decorative North Italian Gothic style.

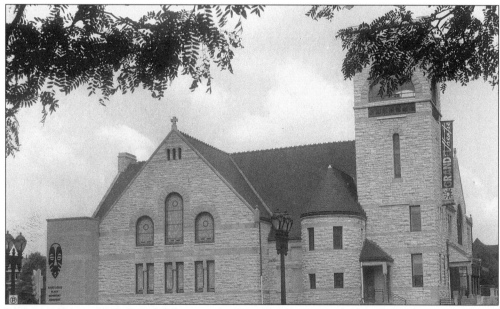

Built in 1884, at 3610 Grandel Square, the First Congregational Church has now moved to a new chapel out in the county. Today called the Grandel Square Theatre, it is home of the St. Louis Black Repertory Company.

Nine

THE 1927 TORNADO

On September 29, 1927, a tornado swept through the West End area; its intensity—though limited to a swath cut through three or four major streets—was deadly. While it wasn't as destructive as the 1896 cyclone, it left a trail of devastation throughout the West End.

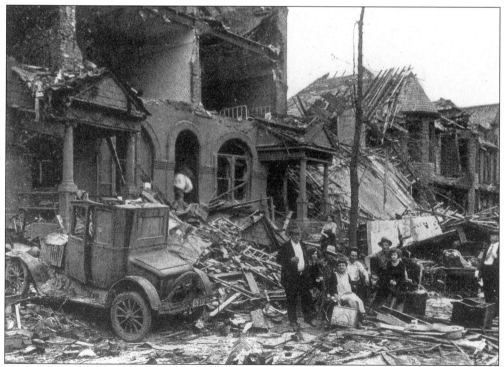

A man stands in disbelief on Sarah at the section of the West End where most of the damage occurred. Cars as well as buildings were contorted and smashed.

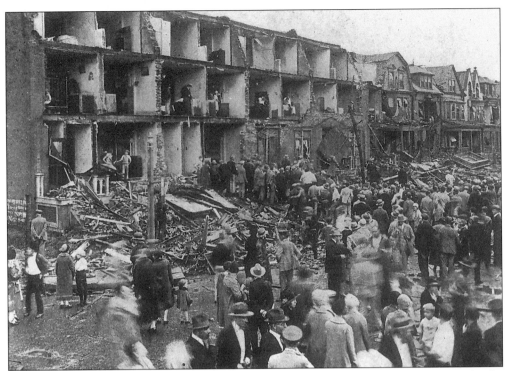

Stunned observers stand in dismay before walls of buildings whose outsides were torn out by the storm's fury.

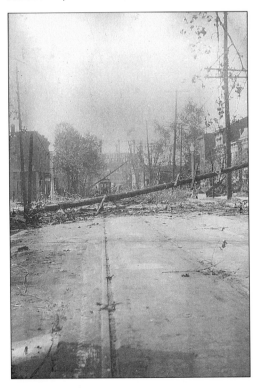

This is a view of Sarah, the street hit hardest by the storm, after the attack. Trees were slashed and thrown against the streetcar tracks, blocking all forward movement.

This is a closer view of a stranded streetcar, immobilized by the storm.

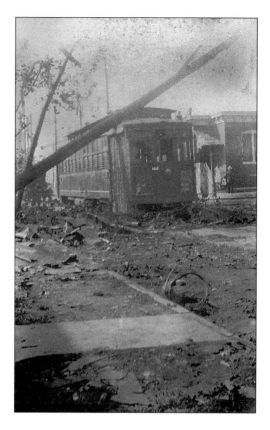

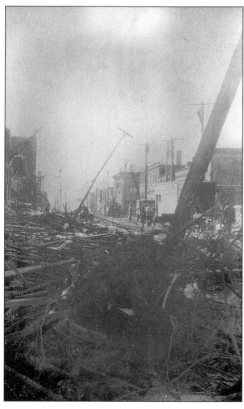

A telephone pole still stood, but only feebly, as the damage continued on Sarah.

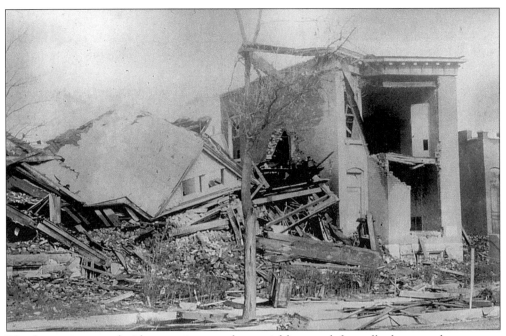

This home was gutted wide open; its next-door-neighbor was left totally devastated.

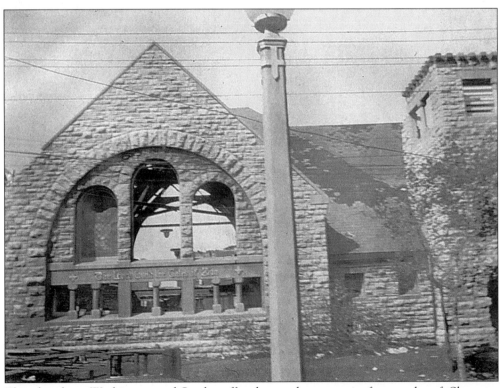

This church, at Washington and Sarah, suffered great damage to its front and roof. Slate was ripped from the roof and its windows were torn out.

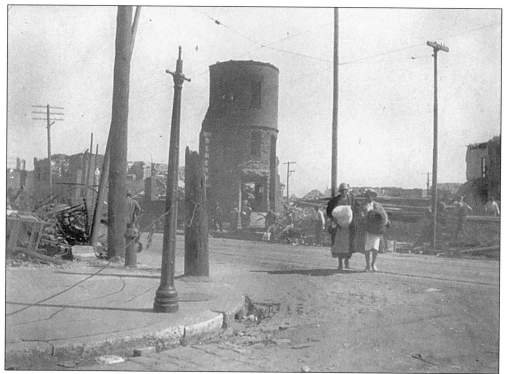

This colored church, located at Cook and Sarah, encountered almost total devastation.

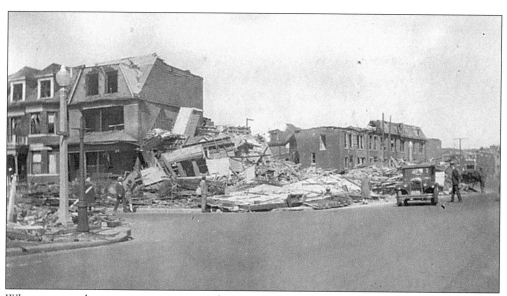

What emerges here in our exposure to this tragic corner scene is the question of how certain buildings survived while others were whimsically destroyed. Here, one building is crushed while others seem only partially damaged.

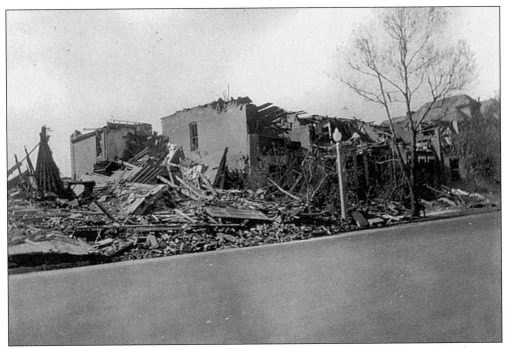

This is another photo of further devastation; this time a lamppost survives while the area around it is pulverized.

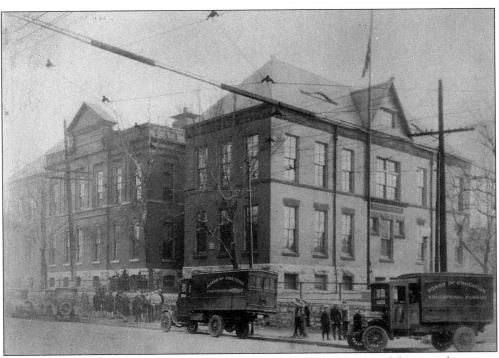

This September 1927 picture shows the Education Museum at the time of the tornado.

Ten

SHOPS, RESTAURANTS, AND MUSIC

Certain prized and sought-after sections of the West End have always provided entertainment and leisure to city dwellers: the Municipal Theatre Association (MUNY), a municipal outdoor theater; Gaslight Square, the once famous night-life center; Midtown, with its symphony hall and theaters; and Euclid Avenue, the Bohemian quarter of town.

The Midtown area, as we have indicated, is again flourishing with a rehabilitated Fox Cinema, the Black Repertory Theater, the St. Louis Symphony, and the Sheldon. Euclid, however, is the heart of the CWE. It is here that the funsters gather for their books, restaurants, bistros, art galleries, and holiday festivities. In passing, we must not forget the great role that the MUNY and Gaslight Square—which, for one moment in the '60s, may have been the "hottest" ticket in the whole country—have played in the life of the town.

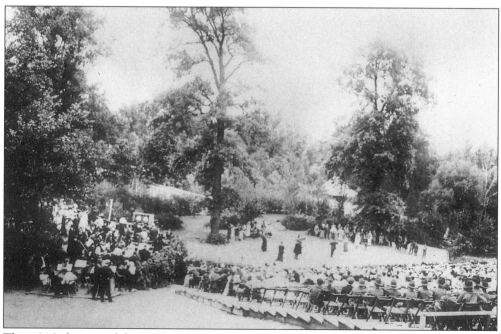

This 1916 photo is of the production of *As You Like It*, on the site that was later to be chosen for a theatre dubbed the MUNY.

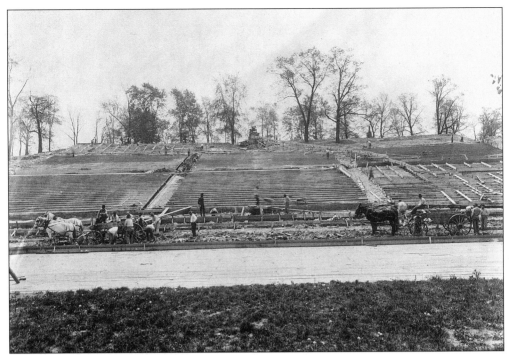

In 1917, under the guidance of Mayor Henry Kiel, the city began constructing a permanent outdoor theatre. This is the construction of seats in the site mentioned previously. The new structure was built in 49 days. The locale is Forest Park.

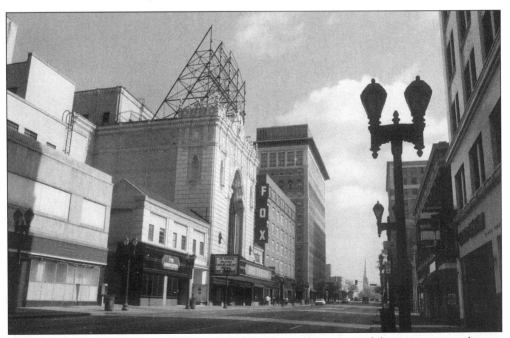

The Fox Theatre was built in Midtown in the extravagant manner of the great cinema houses of the '20s and '30s. Once in decline and deserted, it was rehabbed by the civic-minded Mary and Leon Strauss and stands today in the midst of the buildings on Grand Avenue.

Pictured at right is a view of the luxuriant and opulent interior of the new Fox after its restoration.

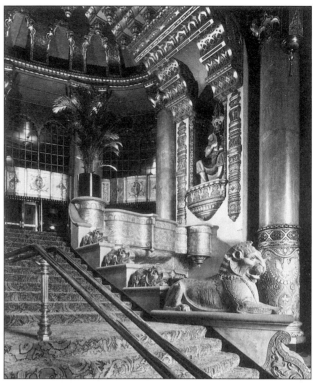

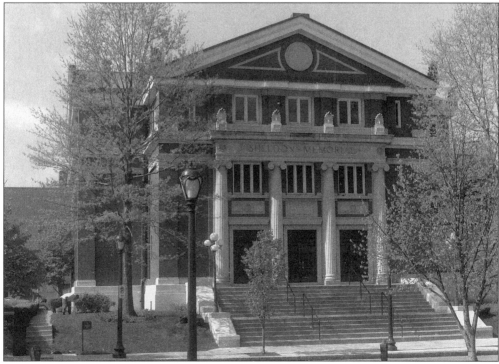

The stately Sheldon Memorial Theatre was recently restored to its former graceful state. With its superb acoustical system, the theatre is considered one of the stars of St. Louis' Midtown.

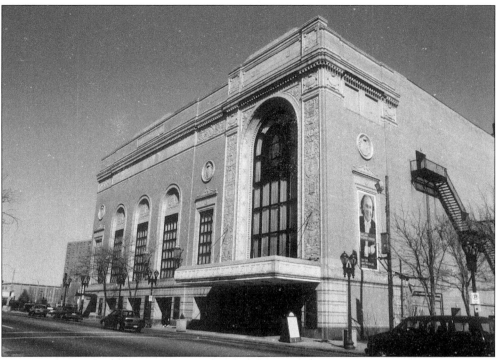

The elegant Powell Symphony Hall, one of the most admired structures in Midtown, is the home of the world-celebrated St. Louis Symphony.

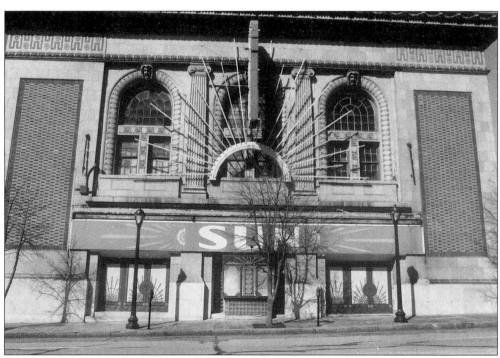

The most historic of all the show places in Midtown is the ancient Sun Theatre. Despite its important role in the history of the town, the theatre is still waiting for renovation.

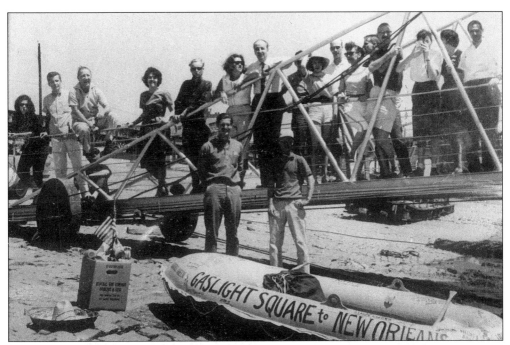

In the midst of the '60s, Gaslight Square blazed forth as an expression of a Victorian past and of a rebellious future. It became, with its theatres and bars, a vital entertainment center that enticed visitors from all over the country. Here, we see a crew heading from the Square to New Orleans, a sister city.

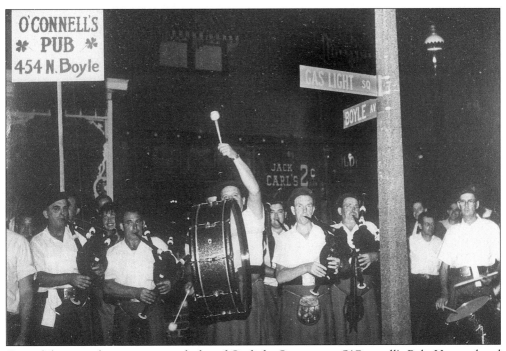

One of the most famous watering holes of Gaslight Square was O'Connell's Pub. Here, a band with placards proclaimed its merits.

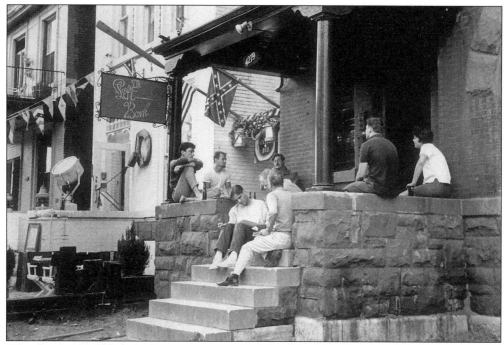

This was a typical Gaslight Square scene—youngsters hanging out at one of the local bars with a Confederate flag waving above them.

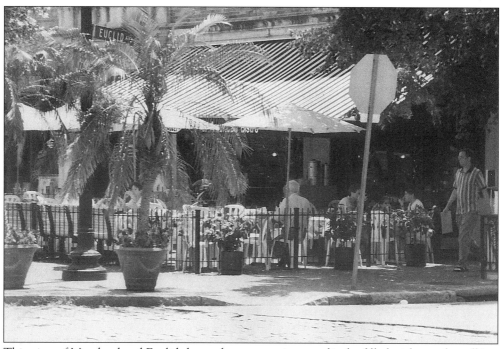

This view of Maryland and Euclid shows the street at its most lively, filled with people walking about or dining.

At this corner of Euclid and McPherson, Left Bank Books stands as one of the finest bookstores of its sort in the city. Able to survive as an independent, it is more than a commercial entity; with its readings, signings, and art shows, it has become one of the great cultural hubs of the town.

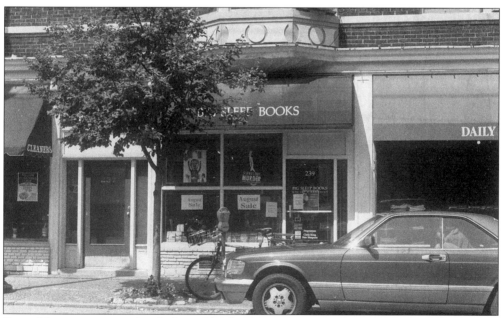

One of the most respected and admired bookstores in the city and on Euclid is Big Sleep Books, owned by the gracious and enthusiastic Helen Simpson, widow of the larger-than-life poet Peter Simpson. Here, Helen charms her way into the life and times of the city with her excellent collection of detective and crime novels.

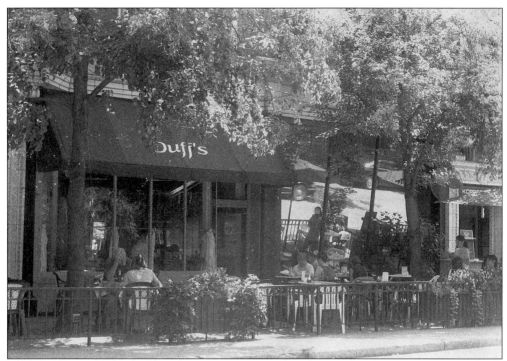

The scene of poetry readings and other cultural activities, Duff's Restaurant, with its excellent food, has become a genuine part of the literary life of St Louis.

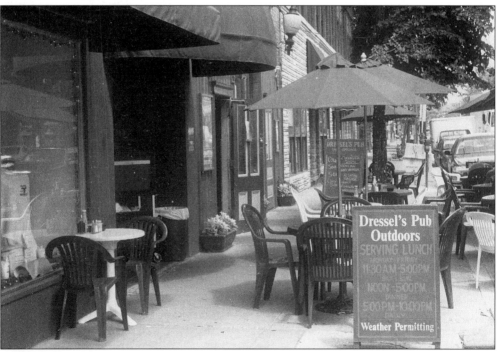

Dressel's Pub is another banner pub which prides itself on ethnic cooking and literary interests; here you see pictures of great writers decorating its walls.

126

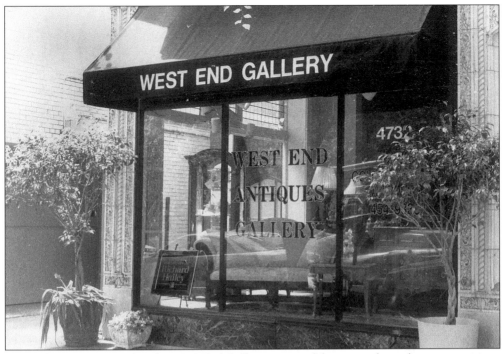

This well-known art studio, the West End Gallery, is one of the many places that entice visitors as they walk along crowded Euclid.

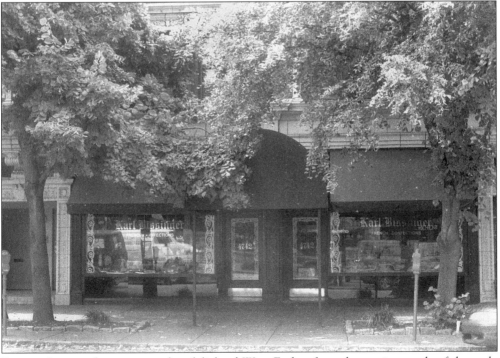

Bissinger's, a candy emporium, has delighted West Enders from the carriage trade of the early century to the happy crews that people the Square today.

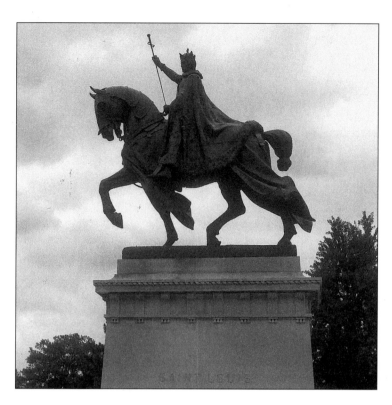

This is a shot of St. Louis (Louis IX of France) for whom the town is named. He rides gallantly from his niche in front of the city's art museum What is it he is thinking? Is it a new future for the city? Will it return to become anew the grand city that once placed him there? Or will the mighty horse be riderless some day? The city must make its choice.

BIBLIOGRAPHY

Anderson, Catherine and Caroline Loughun. *Forest Park*. Columbia, MO: University of Missouri Press and the Junior League of St. Louis, 1986.

Christensen, Lawrence O. and William E. Foley. *Dictionary of Missouri Biography*. Columbia, MO: University of Missouri Press, 1999.

Commemorative History of the Saint Louis Public Schools, 1838–1988. St. Louis: St. Louis Public Schools, 1988.

Compton, Richard J. and Camille N. Dry. *Pictorial St. Louis*. 1875.

Fifield, Barringer and Herb Weitman. "Seeing St. Louis." St. Louis: Washington University Press, 1987.

Goell, Suzanne, ed. *The Days and Nights of the Central West End*. Virginia Publishing Co., 1991.

The Greatest of Expositions: Louisiana Purchase Exposition. 1904.

Hunter, Julius K. *Kingsbury Place*. St. Louis: C.V. Mosby Co., 1982.

———. *Westmoreland and Portland Places*. Columbia, MO: University of Missouri Press, 1988.

"Records by Julius Pitzman." Philadelphia: A.B. Holcombe & Co, 1878.

"Living in Central West End." St. Louis: Central West End Association, 1975.

Morrow, Ralph E. *Washington University in St. Louis*. St. Louis: Missouri Historical Society, 1996.

Stiritz, Mary M. *St Louis: Historic Churches and Synagogues*. St. Louis: St. Louis Public Library, 1995.

Wayman, Norbury L. "Midtown." *History of St. Louis Neighborhoods*. St. Louis: St. Louis Community Development Agency, 1978.